ELLEN LANYON *Transformations*

SELECTED WORKS *from* 1971–1999

with an essay by
DEBRA BRICKER BALKEN

THE NATIONAL MUSEUM OF WOMEN IN THE ARTS, WASHINGTON, DC
December 23, 1999—May 7, 2000

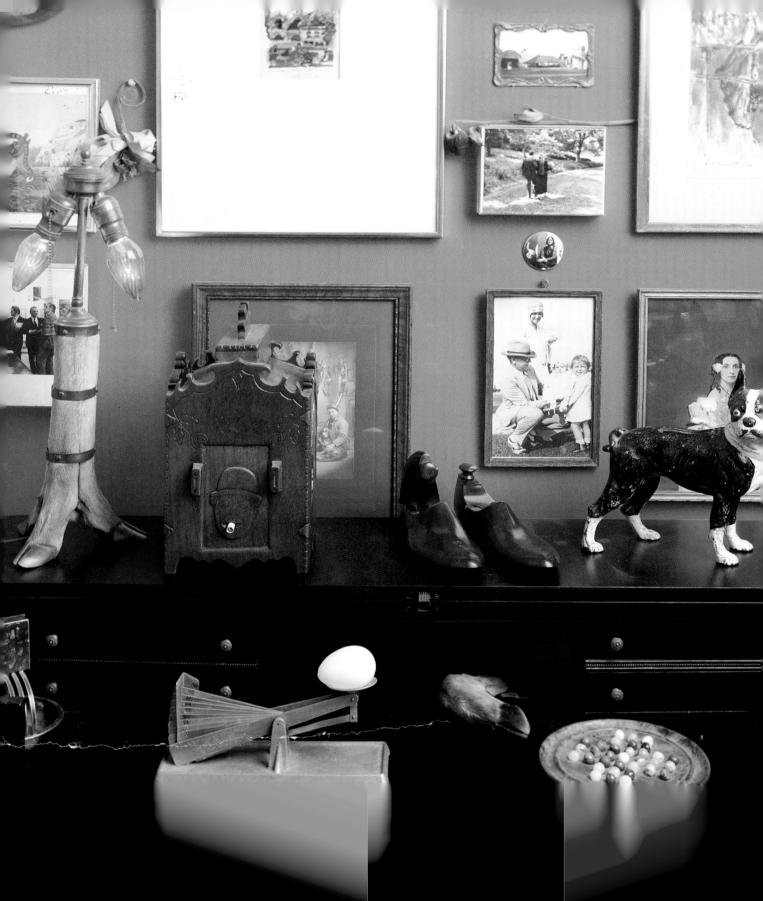

FOREWORD

SUSAN FISHER STERLING, CHIEF CURATOR

The National Museum of Women in the Arts is pleased to present this late career retrospective of Ellen Lanyon's art as part of an ongoing series of Arkansas Gallery exhibitions developed specifically to recognize the accomplishments of mature women artists.

A painter and printmaker of strong talent and intellect, Ellen Lanyon has been described by art historian Lucy Lippard as "a rare and peculiarly American breed—an honest, unpretentious, accessible, visionary artist, not unaware of, but resolutely independent of the imposed mainstreams of fashion." Identified with Chicago Imagism throughout much of her career, she is first and foremost a visual poet. Naturalist and fantasist, her chief artistic concern over the past two decades has been to reveal the correspondences between nature and art as found in all manner of transformations and metamorphoses—physical, magical, scientific, and/or psychological.

As her first major exhibition in ten years, *Ellen Lanyon: Transformations, Selected Works from 1971–1999* focuses upon a theme that has held great importance for the artist since the early 1970s—the toll that scientific and technological progress has taken upon our natural environment. In describing the chain reaction of destruction in the Florida Everglades, for example, Lanyon wrote in *Objects, Wildlife and the Landscape* of 1976:

> *...the imbalance to the saline waters disturbs the eccentric habits of the mangrove's procreation. Drying oolite rejects the apple snail which, in turn, denies the kite its only source of food and so, the obsolescence is assured. Egret, anhinga, pelican and crane are all at stake. Insistent blades of motor boats rip out the necessary feeding beds and scar the gentle manatee. . . . As we charge another missile, the caused disturbance returns the favor with unbalanced weather and violence from within the globe.*

Yet, even before visiting the Everglades, she had already begun to address issues of ecological degradation, filling her box and fan paintings with exquisitely detailed renderings of taxidermic specimens. Through her transformative brand of realism, Lanyon often sought to free these hapless prisoners from their stasis, enabling them through her painting and drawing to spring to life and make their artful escape.

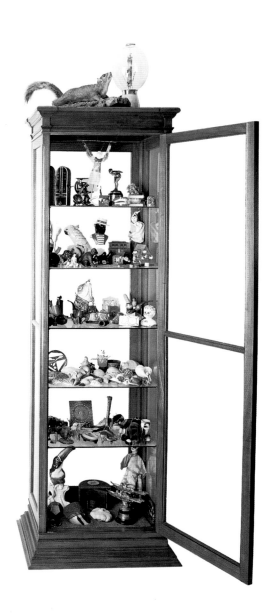

Transformations

SELECTED WORKS *from* 1971–1999

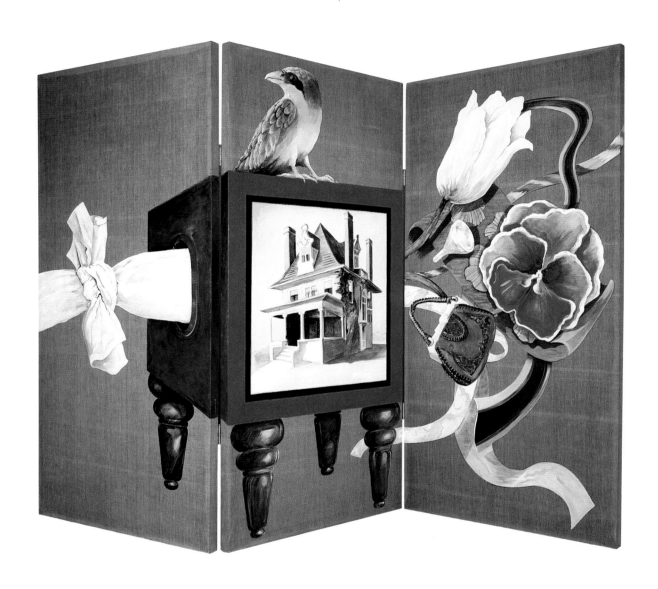

PLATE 1
SILK CABBY, *1971*
60 X 108 IN., *acrylic on canvas, three-panel screen*

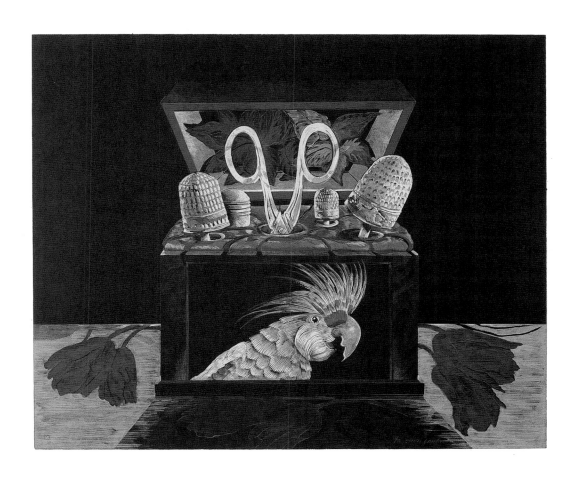

PLATE 2
THIMBLEBOX, *1973*
30 X 36 IN., *color lithograph on black paper*

7

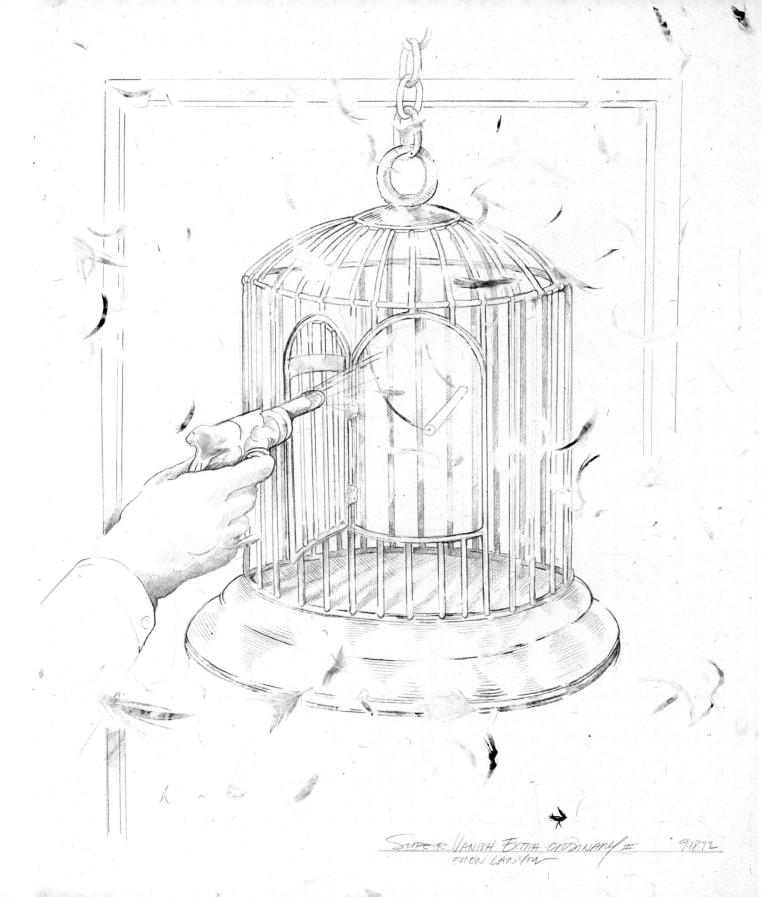

Super Vanish Extra Ordinary III 9.18.72
Ellen Lanyon

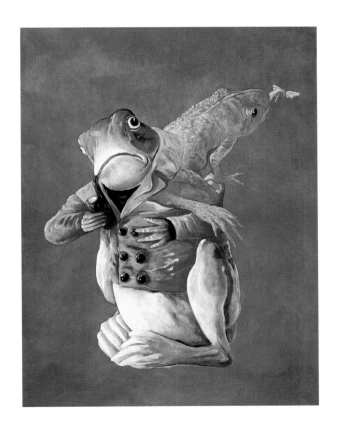

PLATE 4
TOAD, *1978*
48 X 36 IN., *acrylic on canvas*

PLATE 3
SUPER VANISH EXTRAORDINARY, *1972*
21 X 16 IN., *graphite on handmade feather paper*

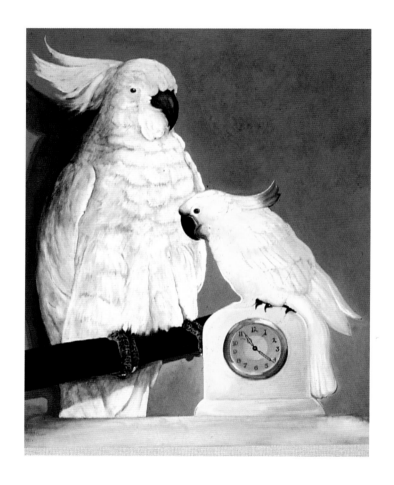

PLATE 5
COCKATOO CLOCK, *1973*
36 X 30 IN., *acrylic on canvas*

PLATE 6
TAMIAMI, *1977*
72 X 48 IN., *acrylic on canvas*

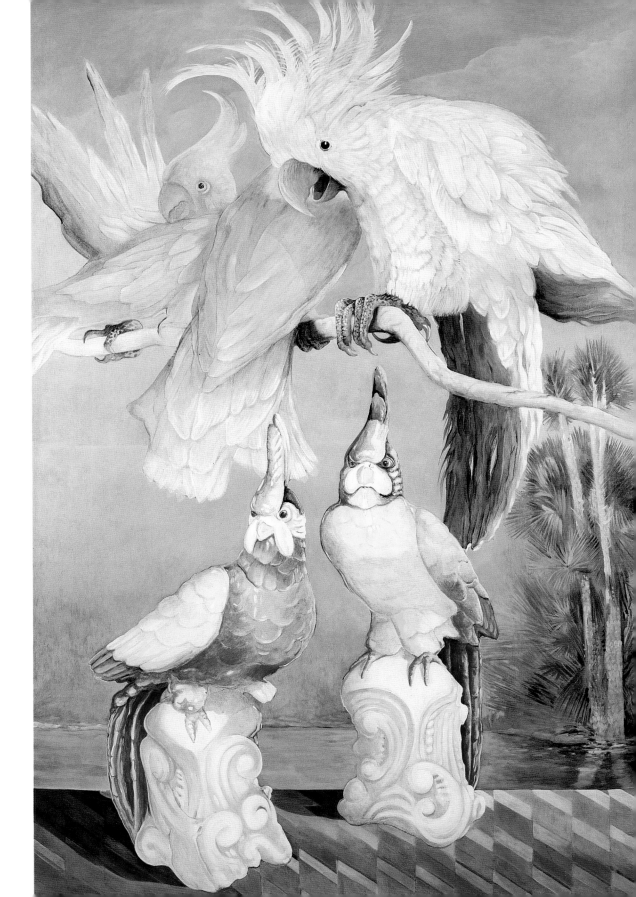

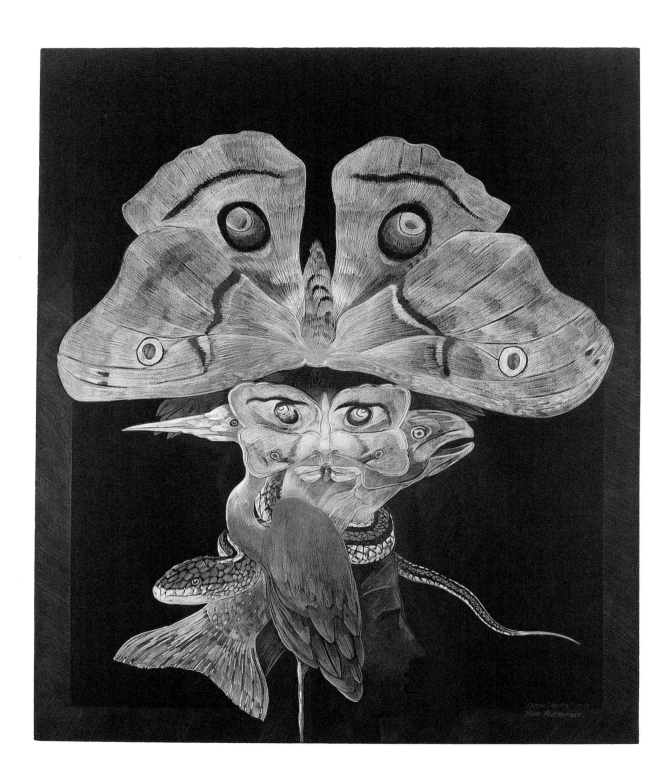

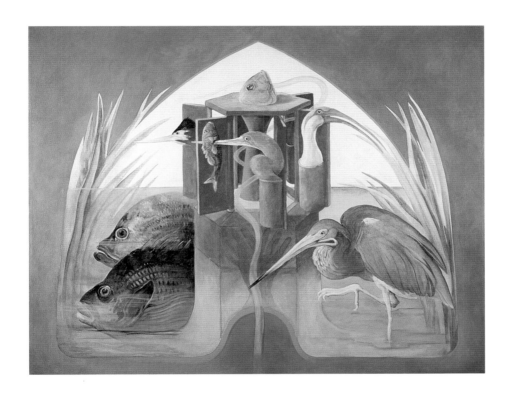

PLATE 7
THE DISGUISE, *1975*
40 X 30 IN., *colored pencil on black paper*

PLATE 8
MRAZEK POND, *1975*
36 X 46 IN., *acrylic on canvas*

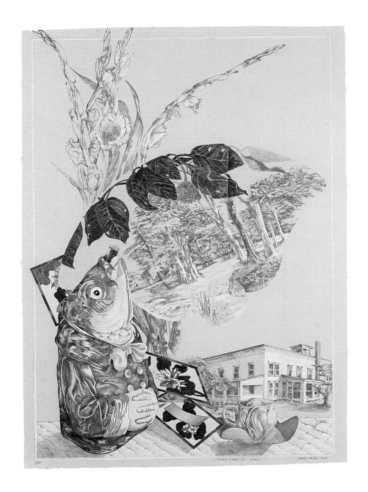
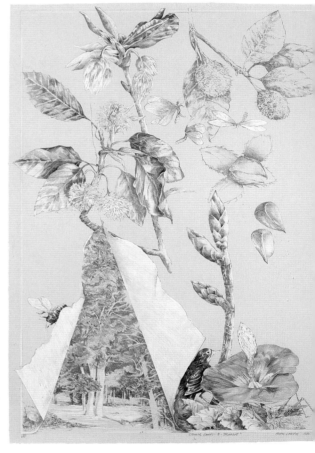

PLATE 9
STRANGE GAMES A, B, C, D, *1981*
48 X 36 IN. EACH, *lithograph with colored pencil on handmade paper*

14

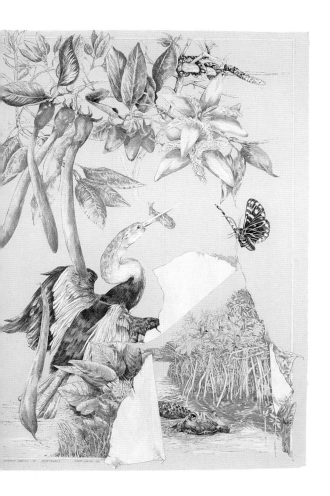

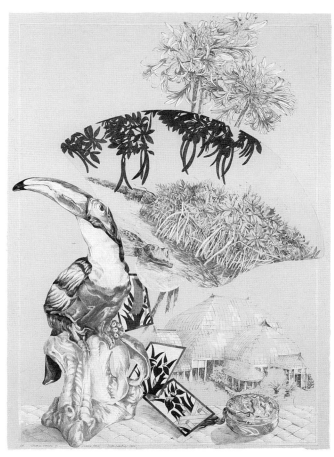

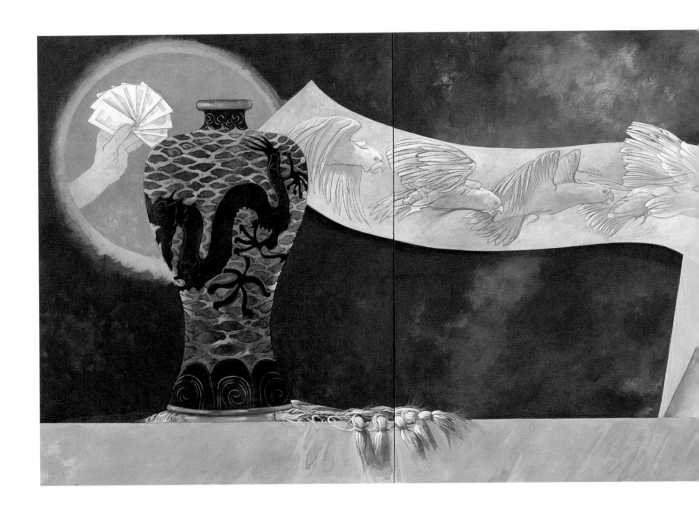

PLATE 10
ENDANGERED, *1982*
48 X 144 IN., *acrylic on canvas*

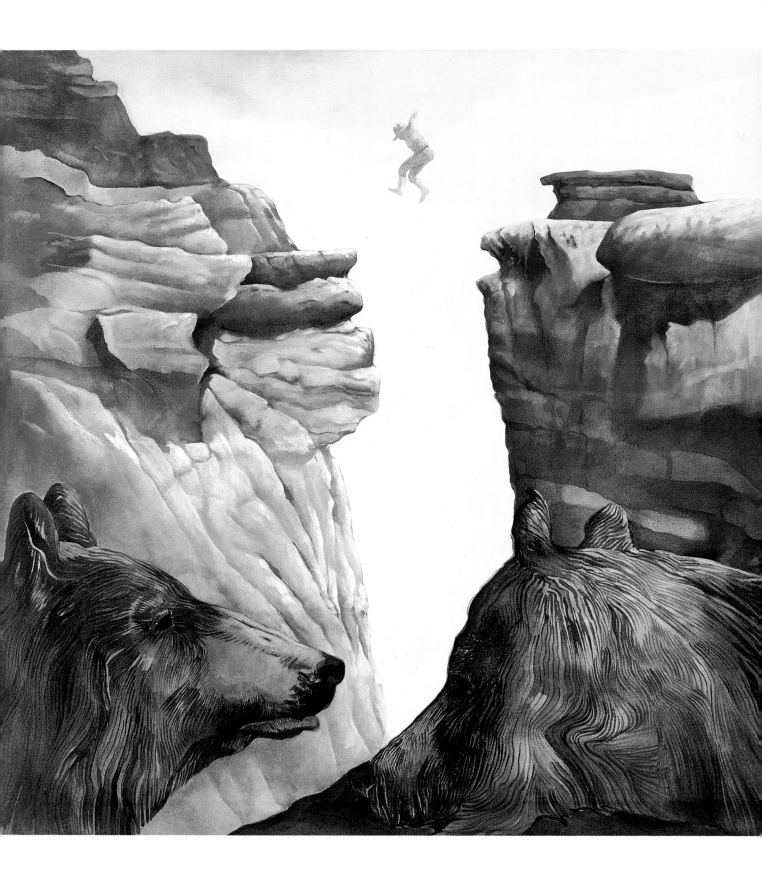

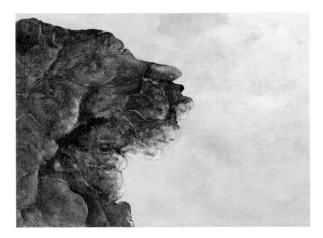

PLATE 12
ROCKFACE I & II, *1986*
12 X 16 IN. EACH, *acrylic on canvas*

PLATE 11
LEAP FOR LIFE, *1984*
48 X 48 IN., *acrylic on canvas*

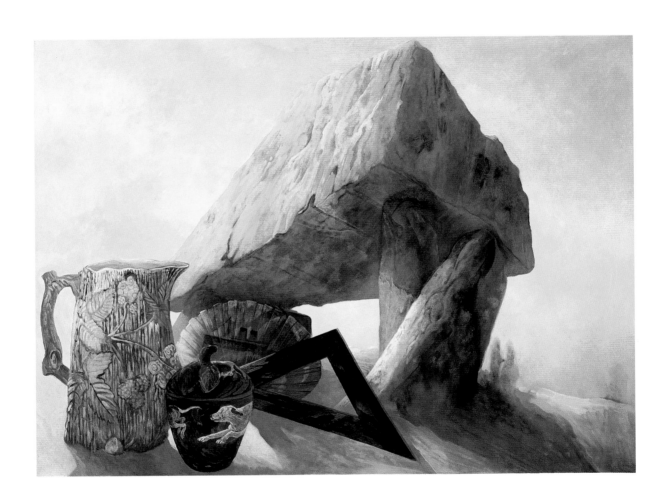

PLATE 13
EVIDENCE OF LIFE/BROWNESHILL, *1989*

54 X 72 IN., *acrylic on canvas*

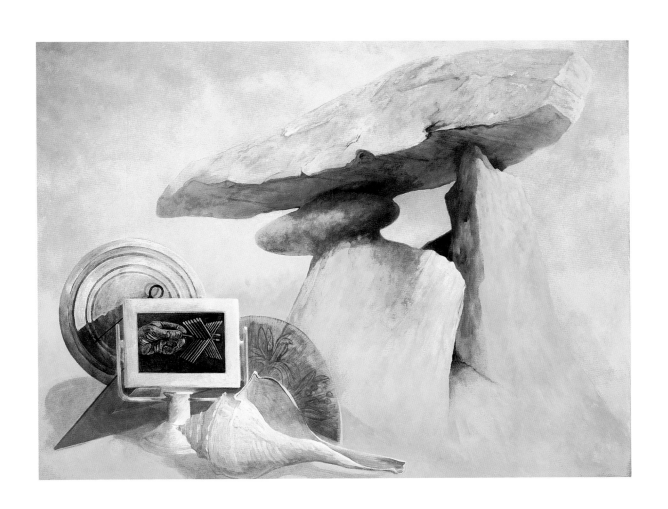

PLATE 14
EVIDENCE OF LIFE/BALLYNAGEERAGH, *1989*
54 X 72 IN., *acrylic on canvas*

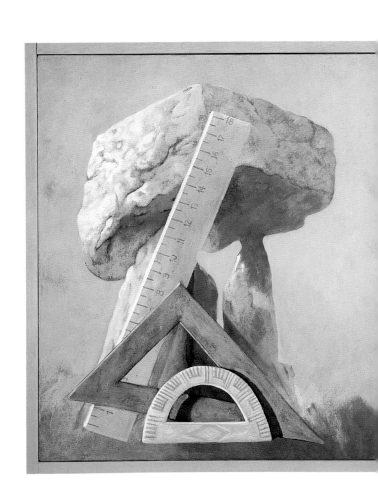

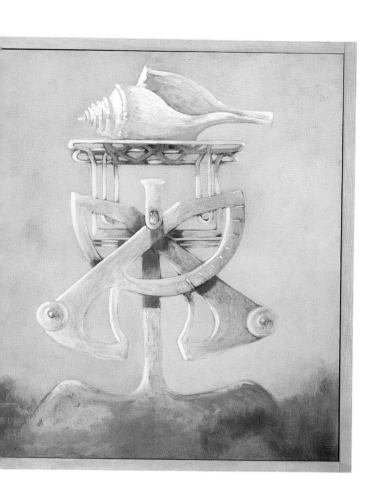

PLATE 15
PROTRACTORED TIME & WEIGHT AND SEA, *1989*
22 X 18 IN. EACH, *acrylic on canvas*

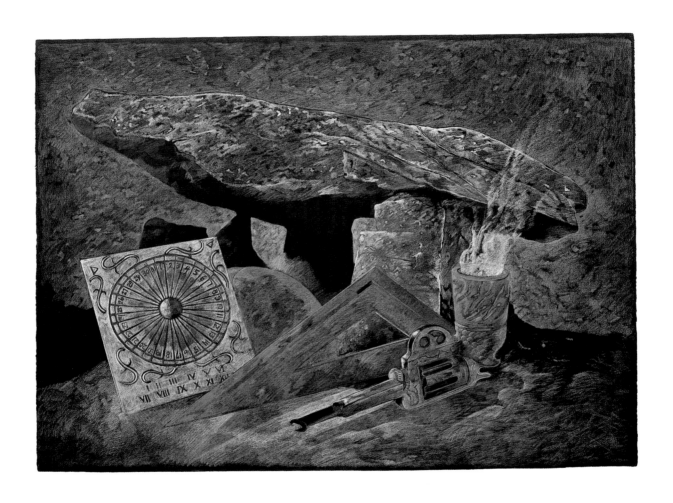

PLATE 16
HISTORY OF THE WORLD I, *1990*
30 X 44 IN., *colored pencil on black paper*

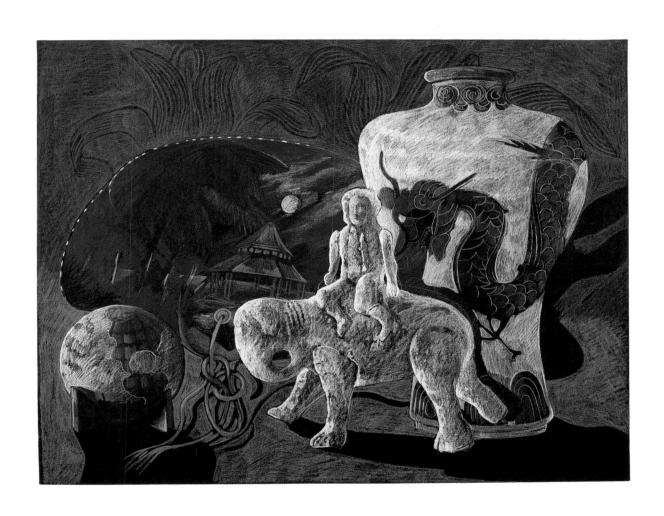

PLATE 17
MIRABAI, *1990*
20 x 30 IN., *colored pencil on black paper*

25

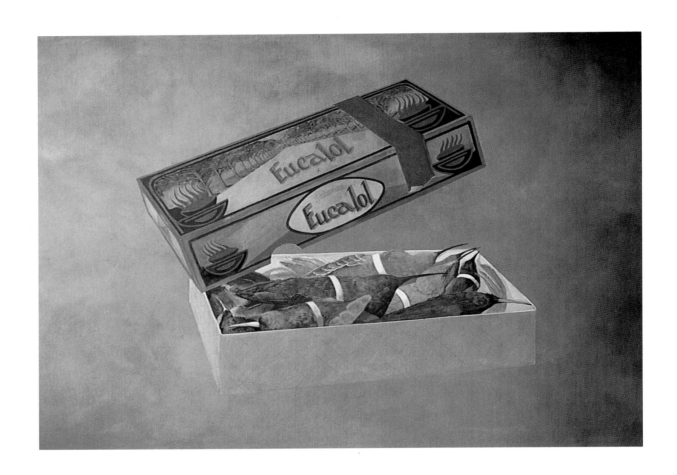

PLATE 18
EUCALOL, *1977*
48 X 72 IN., *acrylic on canvas*

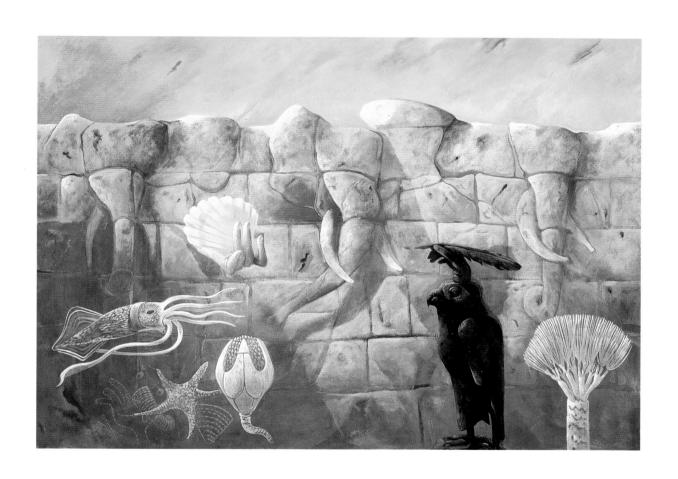

PLATE 19
ELEPHANTINE, *1995*
60 X 84 IN., *acrylic on canvas*

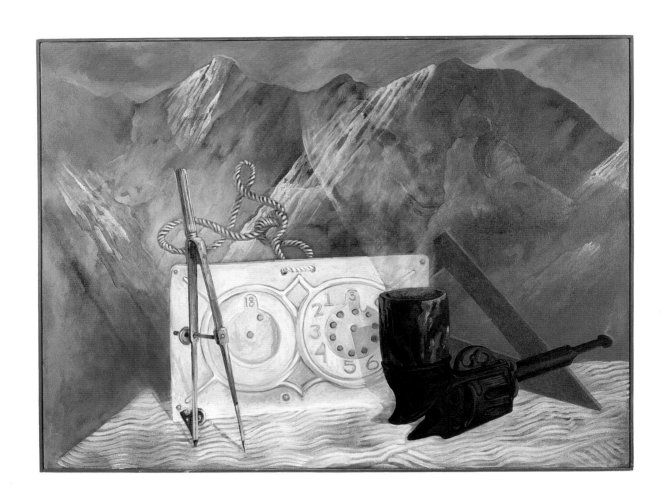

PLATE 20
PERSISTENCE OF INVENTION, *1991*
36 X 48 IN., *acrylic on canvas*

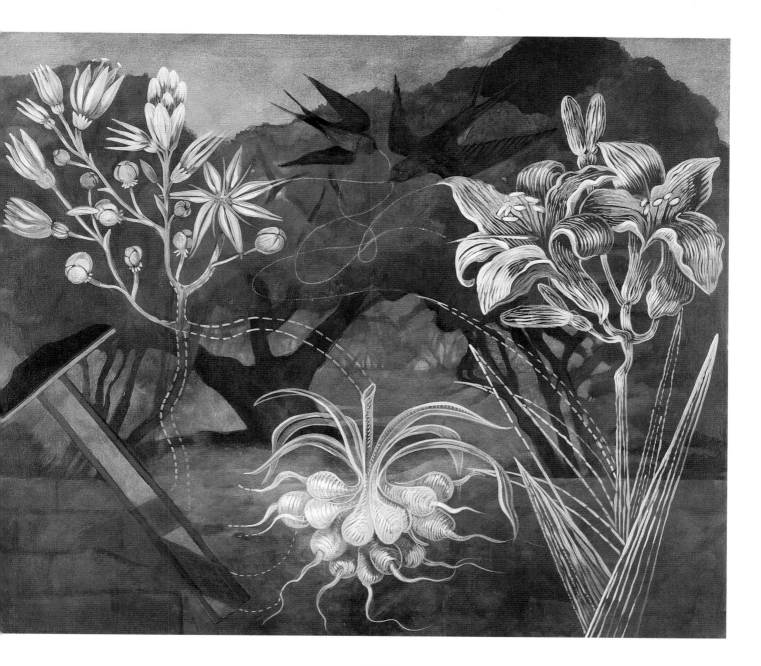

PLATE 21
NAUMKEAG, *1996*
45 X 52 IN., *acrylic on canvas*

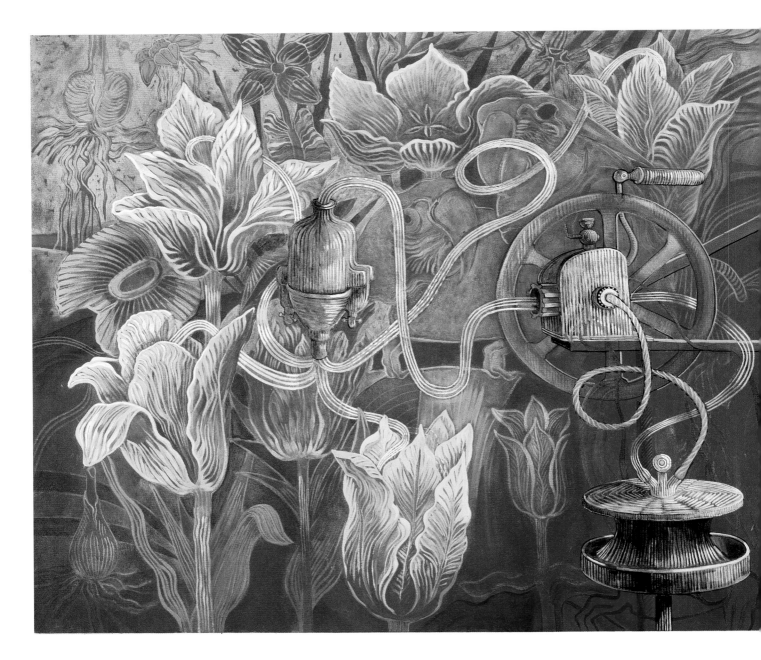

PLATE 22
HOMAGE À POYET/PARROT POYET, *1999*
44 X 52 IN., *acrylic on canvas*

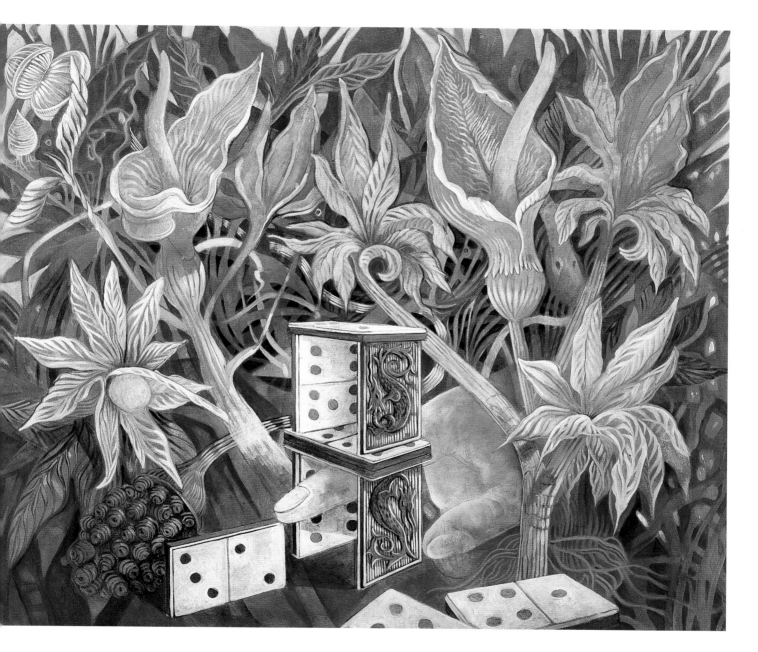

PLATE 23
HOMAGE À POYET/DOMINOES AND DRAGONS, *1999*
45 X 52 IN., *acrylic on canvas*

Ellen **LANYON'S** *Unintentional Surrealism*

DEBRA BRICKER BALKEN

Stories about weirs, and sudden floods, and leaping pike, and steamers that flung hard bottles—at least bottles were certainly flung, and from steamers, so presumably by them; and about herons, and how particular they were whom they spoke to; and about adventures down the drains, and night—fishings with otter, or excursions far afield with Badger.
—KENNETH GRAHAME, *The Wind in the Willows*

Ownership is the most intimate relationship one can have to objects. Not that they come alive in him; it is he who lives in them.
—WALTER BENJAMIN, *Illuminations*

OF ALL OF THE MEMORIES THAT ELLEN LANYON RECOUNTS FROM HER CHILDHOOD, PERHAPS THE ONE THAT IS THE MOST RESONANT, OR AT LEAST THE ONE THAT CORRESPONDS MOST DIRECTLY TO HER WORK'S IMAGERY, IS HER RECOLLECTION OF THE MIDGET VILLAGE AT THE CHICAGO WORLD'S FAIR IN 1933. In Lanyon's retelling, this magical space inhabited by midgets was filled with surreal overtones, an environment that approximated a doll's house and that allowed for the enactment of fantasy and fulfillment of desire through material form. The story is made all the more winsome by Lanyon's fondness for her beloved grandfather, Fred Aspinwall, an artisan who worked at the fair and who deemed the strange creation an ideal play site for Lanyon and her siblings. Imagine the awe and bewilderment of an eight-year-old girl interacting "with people of [her] own scale" in an adult yet seemingly storybook setting.[1] The incident, with all its Oz-like ingredients, revealingly encapsulates what was to become a narrative trope in Lanyon's work, for along with the deft realism and beguiling facility with which she renders her subjects, her paintings have always dealt with some aspect of the marvelous.

Part of what Lanyon carried with her from this singularly "weird" experience, as she describes it, was a sense of scale and exacting detail that could be employed to heighten or escalate the dimensions of real spaces and incidents for an illusionary effect.[2] In her *Magic Series*, Lanyon's paintings forgo an earlier preoccupation with the family, with representations of her spinster aunts and the various domiciles of her youth in Chicago, in favor of disjunctive, quirky combinations of animals, objects, and eccentric inventions that better mine her latent but repressed metaphysical interests. She remembers around 1966 a distinct urge and "change to the use of the inanimate," that is, a move toward "controllable descriptions of manipulated phenomena: Physics, Formulas, Prestidigitations. The animal world announced itself. . . . It was what I had looked for all along but could not focus on. The substitution of creatures domestic and wild for the dramatization of the human condition."[3]

What, for example, brought on the fantastic disarray of wildlife, of exotic butterflies and birds that appear to issue from a siphon bottle in *Chemistry Versus Magic* (pl. 24) in a kind of surreal opposition between science and the supernatural? While Lanyon has always claimed that her imagery is unconsciously derived, surfacing from the recesses of her memory and imagination with little or no examination, certain events and encounters in her life in Chicago from the mid-1960s to the early 1970s seem to have evoked what emerged on canvas as a renewal of childhood enchantment and a sense of the strange and transcendent—feelings first elicited by her experience at the Midget Village.

Part of the content of the *Magic Series* was shaped by Lanyon's introduction to the eccentric vocational interests of a neighbor, Mr. Miller, who worked in a rented store in the Capital Hotel across from her home on Clark Street. Mr. Miller was a former stage magician, who in his retirement constructed props, such as magician's boxes, for professional prestidigitators. The implements and performance that surrounded the staging and spectacle of magic, as revealed by Mr. Miller, became for Lanyon a source of intense curiosity as well as material for her work. Though she realized that film, with all of its illusionary properties and ability to deceive through its pseudoreality, could be a perfect medium for her new interests, she opted instead to "make magic on a two-dimensional surface,"[4] extending Mr. Miller's wizardry to the conventions and format of painting.

The magical images and metaphors Lanyon conjured on canvas are, however, layered with intensely personal and sexualized meanings. In *The Italian Box*, 1973 (pl. 25), for instance, a magician's box, embellished with faux marbling and set in a lucent mountainous landscape, becomes an agent for allegory—a morality tale on the nature of good and evil. While the upper area of the tiered box contains luscious chocolates, the bottom drawer holds a snake that has entered the box from the rear. To Lanyon, the chocolate is deceptive—sweet, "but forbidden because it is bad for you." The snake is, ironically, a "classical symbol of rejuvenation because of its ability to shed its skin."[5] Notwithstanding the snake's clear phallic connotation and malevolent associations, *The Italian Box*, like all of Lanyon's work from this point onward, thrives on a play of opposites and on the use of elusive yet erotically charged meanings that can be generated from the combination of ostensibly unrelated objects.

While *The Italian Box* is entirely fictitious, based on fantasy rather than on an existing form, most of Lanyon's imagery is taken from actual objects, all of which are part of an extensive collection that she has amassed. Like the idiosyncratic combination of birds, butterflies, and the siphon bottle in

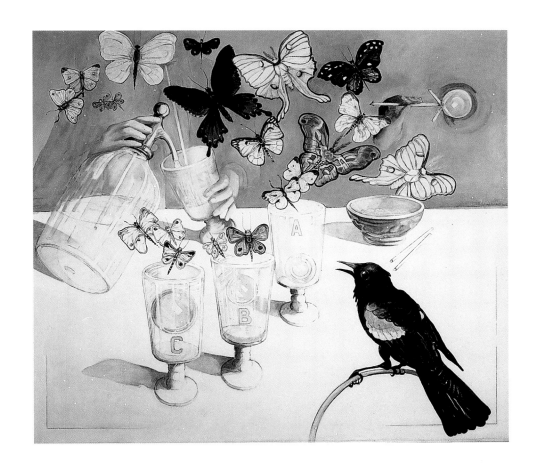

PLATE 24
CHEMISTRY VERSUS MAGIC, *1970*
60 X 60 IN., *acrylic on canvas*
Letitia and Richard Kruger Collection, Chicago

Chemistry Versus Magic, Lanyon's collection of vintage postcards, quirky porcelain figurines, pipes, magic boxes, and taxidermy specimens is equally as capricious. Such souvenirs reflect a certain whimsy and longing to be surrounded by things that have some connection to her past or to her fanciful construction of a world of miscellanea, of trinkets and odds and ends that allude to a magical yet coherent place. Lanyon has stated that her accumulation of bric-a-brac is in keeping with a trait among Chicago artists to form collections of some sort. The Hairy Who, for instance, were attracted to the paintings and drawings of the so-called Outsiders, as well as to tribal objects and to works incorporated within craft and folk traditions. According to Lanyon, there is something about Chicago and "its work ethic that leaves very little room for the imagination" and encourages the internalization of fantasy and creation of intensely private spaces.[6]

While Lanyon had always been drawn to flea markets, antique stores, and resale shops to fuel her imagination and enhance her collection, around the time she met Mr. Miller in 1970, she also encountered a number of collections in Chicago that contained important Surrealist works that both posited and extended many of the ideas present in her work. In the Edwin and Lindy Bergman Collection, she came across the work of Joseph Cornell, whose boxes, with their miniaturized worlds and dreamlike spaces, are replete with enchantment as well as an enigmatic, unknowable intelligence. She was similarly influenced by paintings in the Joseph R. Shapiro Collection, especially works by René Magritte and Paul Delvaux. Magritte's paintings, in particular, would soon imprint Lanyon's work through her frequent references to suspended pipes, a trademark image of the Belgian Surrealist that Lanyon excavated for both its pedestrian ambiguity and erotic subtext.

These art historical prototypes reinforced Lanyon's sense of the absurd and the surreal dimension of seemingly ordinary objects, but the largest stock of her images was derived, outside of her collection of souvenirs, from offbeat and quirky books, such as *Thayer's Quality Magic*; a sales catalogue with copious illustrations of coin, magic, and card tricks; and *Stage Illusions*, a how-to book on the various ways to perform such magic tricks as the "The Glass-Lined Trunk" and "The Mysterious Lady."[7] *Thimblebox*, 1973 (pl. 2), Lanyon's homage to Cornell, juxtaposes devices of illusion with a cockatoo that has been magically spared the blades of a pair of scissors. This sewing box, with its thimbles and scissors, is erotically suggestive, a symbol of withheld castration that imbues the combination of wondrous and commonplace imagery with a sense of uneasiness. Similarly, *Super Vanish Extraordinary*, 1972 (pl. 3), a drawing on feather paper, dramatizes another stage production from *Thayer's Quality Magic*.[8] Here, a bird has disappeared from its gilded, ornate cage, apparently shot by a blast from a gun. Or has it been? While the flutter of feathers alludes to its vanishing, no other trace of the bird remains, an illusion that operates through a visual sleight of hand.

Much as *Thayer's Quality Magic*, among other books, has served as an ongoing repository of imagery for Lanyon since the early 1970s, so too have the contents of her equally odd and curious collection. The cockatoo in *Thimblebox*, for example, comes from a porcelain figurine that resides in one of her many curio cabinets (pg. 4). An Art Deco clock whimsically topped by a ceramic bird likewise inspired *Cockatoo Clock*, 1973 (pl. 5). Many of these objects initially came from the home of her paternal grandfather, Dick Lanyon, a collector of antiques and bric-a-brac, as well as from her spinster aunts, who always had "wonderful treasures" in their apartments.[9] When her

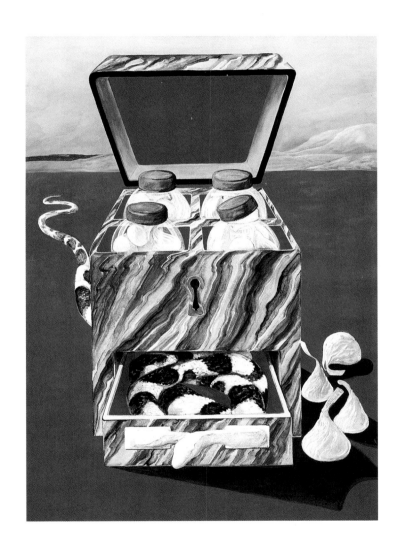

PLATE 25
THE ITALIAN BOX, *1973*
42 X 32 IN., *acrylic on canvas*

grandfather's household in Englewood was dispersed, she "didn't take the Dresden china, nor the Haviland dinner set, but I did take all the strange and unusual objects that had been around the house."[10] Some of these, like her grandfather's tobacco jar, have become the subjects of paintings such as *Toad*, 1978 (pl. 4), the jar here recast to form a wry juxtaposition of animate and inanimate life, of the natural and the cultural, as a toad extricates itself (like magic) from its ceramic incarnation.

However fixed a souvenir in Lanyon's collection, the transformative, whimsical tobacco jar also signifies the shape of her childhood reading—of favorite books like *The Wind in the Willows*, in which the toad figures prominently, and the Oz book series, in which the transformation of reality into dreams and possibility is a unifying leitmotiv. Although Lanyon has stated that she "has always tried to not be too conscious with anything and where it comes from, and why it's there, and why I do it,"[11] she does recall a certain austerity and absence of frivolity in her home as a child (unlike that of her maternal grandfather's), a condition that drove her to indulge in reading as many travel books as she could find in her neighborhood library.[12] This desire to be magically transported to some splendid foreign place clearly marks Lanyon's work from around 1970 onward.

Almost all of the images that appear in Lanyon's work are copied or taken from cultural sources, such as her souvenirs, postcards, and books, rather than drawn from life. The issue of appropriation, of duplicating a found image, reveals as much about her working practice as it does about the thematic ideas that govern her work. Lanyon has noted that "all through the photographic era, I taught myself how to draw. I really did become a rather good draftsman and it was because I pursued it working from photographs and drawing the situation out. . . . The photograph was really like an object, a source."[13] Unlike the subversive intent of many contemporary artists who scavenge images from advertising and the mass media, Lanyon's representations of animals, fanciful figurines, and wondrous objects are devoid of irony, emanating as they do from arcane and unconventional sources. Appropriation is almost an automatic process for Lanyon, rather than an ironic conceit. As a child of the Depression, Lanyon was sent to work at the age of fifteen to assist with the household income. She found work in the drafting department of the Beardsley & Piper Company, where she enlarged preexisting designs for mechanical parts. Though she subsequently attended the School of the Art Institute of Chicago, this early experience was formative and lasting, with its emphasis on skill and the exact replication of intricate objects. It explains, in part, the distanced nature of all of her painting and drawing—an ethereal, faraway reverie filtered through the fastidious re-creation of specific items and gadgets.

After her *Magic Series*, Lanyon produced works given to endangered species, to the threatened and ephemeral life of the Everglades, which she saw for the first time in the mid-1970s. Even in her sketches of wildlife, Lanyon integrated renderings of found photographic images taken from travel, natural history, and conservation magazines, as well as from her now-ubiquitous recastings of magical boxes and cherished figurines. Much as the natural is contrasted with the artificial in *Toad* and other works, Lanyon's reflections on vanishing ecosystems convey an implicit understanding that these sites and sanctuaries are just as magical and perhaps even more mysterious than the elusive objects and fragments that fill her curio cabinets and shelves. In *Mrazek Pond*, 1975 (pl. 8), a painting that grew out of her experience in the Everglades, nature is depicted as a surreal apparition that has been thoroughly imprinted by

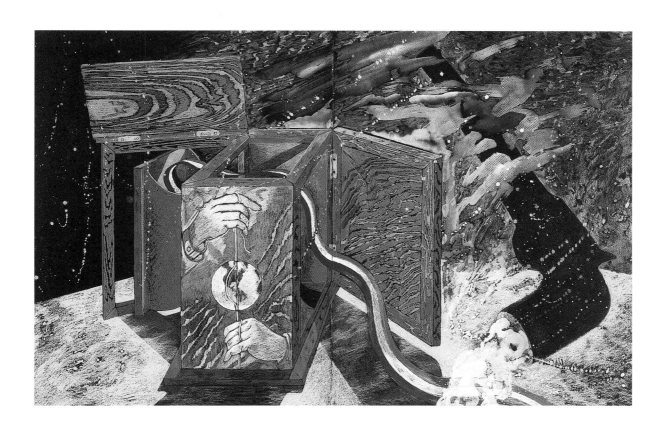

PLATE 26
THAYER'S (DIS) ILLUSION, *1992*
25 X 40 IN., *colored pencil and gouache on black paper*

culture: a cigarette box framed by the compositional form of a fan (another category of objects that Lanyon collects) contains a number of fish, together with egrets and storks that float within a luminous space.

As a child, Lanyon never lived near wilderness, let alone came into contact with it. Nature remained a distant entity or fiction until her realization in the mid-1970s that the exotic, fragile species she observed in Florida were as rarefied as the souvenirs in her collection. This awareness led to a series of landscapes that glorify the eccentricities of nature but curiously dispense with the allegory and binary juxtapositions that informed the narratives of her *Magic Series*. Though *Leap for Life*, 1984 (pl. 11), for example, alludes to a vintage postcard of a legendary park ranger who jumped across a chasm in Wyoming, Lanyon's version of the event resulted from her trip out West, where she again discovered how nature's spectacles and magic could yield multiple possibilities for her work. In rock formations, especially the gorges, rifts, fissures, and ravines she saw in the national parks of Wyoming and Montana, the uncanny resemblances to human shapes became subjects for paintings that were rendered without cultural fixtures or accompaniments. *Rockface I & II*, 1986 (pl. 12), depicts the profiles of rocky outcrops without alteration or enhancement of their innate, peculiar anthropomorphism.

By the end of the 1980s, these forays into straight landscape gave way to the symbolic statements and parables that have become the mainstay of her work. Lanyon's clever conjunction of man-made contraptions and the natural world has proved to be a potent formula, offering endless spins on an age-old dualism. *Protractored Time & Weight and Sea*, 1989 (pl. 15), *Evidence of Life/Browneshill*, 1989 (pl. 13), and *Persistence of Invention*, 1991 (pl. 20), for example, are packed with metaphor. The purposefully disjunctive combination of mechanical instruments and measuring sticks with landscape features is emblematic of the history of time. Such instruments also symbolize the inability of science to extract coherence and meaning from its study of nature, for all these antiquated inventions that Lanyon has found in her weekly visits to flea markets have been deemed too quirky for ongoing use. They are the cast-offs or fragments of disappearing cultures.

Less sexualized and more elegiac than the imagery in her *Magic Series*, with its serpents, scissors, and pointed phallic symbols, these still-life arrangements set within landscapes emerge as statements about the loss of magical natural environments and the ascendancy of science and technology. Through her polarized objects and settings, Lanyon suggests that history is nonteleological—that it unfolds and becomes constructed and reconstructed through the surfacings of random, sometimes peculiar artifacts that curiously chronicle and presage the shortcomings of current culture. The T-squares, yardsticks, and balances that attempt to quantify the megaliths and conch shell in such paintings as *Protractored Time & Weight and Sea* are incapable of measuring the mysterious presence of these natural objects. While Lanyon continues to thematically structure her work by juxtaposing opposing ideas, objects, and scenes, her recent paintings and drawings exude a certain sobriety that contrasts with the more wondrous, transcendent nature of her *Magic Series*. The topic of extinction, she knows, requires less metaphysical treatment. Nature's eccentricities and spectacles are still pursued for their enchantment, but they are now accompanied by a morality that questions the values and priorities of a culture willing to diminish nature.

Many of Lanyon's paintings and drawings from the late 1980s through the 1990s chronicle her travels to diverse places such as Ireland,

England, Italy, Egypt, and Japan, as well as her acquisition of new objects and visual sources for her ever-expanding collections. In *Evidence of Life/Ballynageeragh*, 1989 (pl. 14), the dolmens and cairns Lanyon visited in Ireland appear with assorted collectibles (here a mirror, conch shell, and several measuring devices). In *Elephantine*, 1995 (pl. 19), by contrast, her souvenirs give way to imagery conjured by the scene's exotic locale. Sketched while on a trip to the gardens at Bomarzo, Italy (the ultimate rock fantasy), this work depicts a massive stone wall configured to resemble a row of elephant trunks overlaid with delicate, transparent images of prehistoric squid, shells, fossilized underwater plants, and a sculpture of Horus, the Egyptian god of light. Lanyon has stated that her "travels always have an impact on her work" and that they continue to reinvigorate and redirect the overarching narratives of her painting.[14] Like the Midget Village and the books she read as a child, the sights she has encountered in her travels reinforce her view that reality has its own bizarre, weird, and unexplainable components—peculiarities that disrupt whatever coherence and order science and its inventions have projected onto the world.

Lanyon has claimed that the incongruous array of imagery upon which she has drawn over the past three decades reveals an "unintentional Surrealism,"[15] a declaration that insists not only on the spontaneous, unconscious generation of the tropes that make up her work, but also on the indirect relationship of her work to historic movements and contemporary precedents.[16] As an artist from Chicago, Lanyon identifies with the Imagist tradition that came to identify the preoccupations of many artists of that city, especially from the 1950s onward. But her particular interpretation of fantasy, of worlds with magical objects and alien settings, is wholly her own.

In *Thayer's (dis) Illusion*, 1992 (pl. 26), Lanyon portrays a box given to her by Mr. Miller, along with an image of a globe—a sad but poignant metaphor for the professional fate of the stage magician whose hands eventually lose their nimbleness and can no longer concoct illusions. These dual images, the magic box and the globe, are also emblematic of Lanyon's belief that illusion and reality, the fantasy world and the real world, are integrally entwined, and if one half of the polarity collapses or loses its balance, a richness of visual meaning can no longer be sustained.

NOTES

1. Ellen Lanyon, interview by Jim Crawford, 5 December 1975, Archives of American Art, Smithsonian Institution, Washington, D.C.

2. Ibid.

3. Ellen Lanyon, in *Ellen Lanyon* (Chicago: N.A.M.E. Gallery, 1983), 13.

4. Ellen Lanyon, interview by author, tape recording, New York, N.Y., 25 April 1999.

5. Ibid.

6. Ibid.

7. In addition to *Thayer's Quality Magic* (Los Angeles: Thayer's Studio of Magic, n.d.) and Will Goldston, ed., *Stage Illusions* (London: Magician Ltd., n.d.), the stock of books from which Lanyon has derived the bulk of her images include such disparate sources as J. Tom Burgess, *Knots, Ties, and Splices: A Handbook for Seafarers, Travellers, and All Who Use Cordage* (London: George Routledge and Sons, n.d.); Bjorn Kjellstrom, *Be Expert with Map and Compass: The Orienteering Handbook* (New York: American Orienteering Service, 1955); *Das Neue Universum* (Stuttgart: Union Deutsche Verlagsgesellschaft, n.d.), a book of illustrations of turn-of-the-century machines and inventions; J. S. Coward, *The Coward Shoe* (New York: J. S. Coward Company, 1908), a sales catalogue of shoes; and John Parkinson, *The Garden of Pleasant Flowers* (1629; reprint, New York: Dover Publications, 1976). All are consulted by Lanyon simultaneously for her work. Moreover, she also collects books of vintage wallpaper, which she has used as sources for some of her most recent paintings, as well as photocopies of folios from books and inventions by Louis Poyet, a French inventor who worked at the turn of the century.

8. This paper was made by Joe Wilfer, a friend and papermaker, who also introduced Lanyon to *Thayer's Quality Magic*.

9. Lanyon, interview by author, 25 April 1999.

10. Lanyon, interview by Crawford, 5 December 1975.

11. Ibid.

12. Lanyon, interview by author, 25 April 1999.

13. Lanyon, interview by Crawford, 16 January 1976, Archives of American Art, Smithsonian Institution, Washington, D.C.

14. Lanyon, interview by author, tape recording, New York, N.Y., 30 May 1999.

15. Ellen Lanyon, quoted in Franz Schultz, "Two Chicago Printmakers: Conversations with Vera Berdich and Ellen Lanyon," *Artnews* (March 1974): 66.

16. Ellen Lanyon, telephone conversation with author, 10 June 1999, maintained that while she had seen collections of Surrealist material in Chicago around 1970, they reinforced rather than influenced her prevailing interests. Similarly, on the issue of feminism, which many writers have used as a means of interpreting her work, Lanyon has stated that "I was probably working within this context for years before I realized it and after it was pointed out to me by others and by myself, I've been very careful not to think of it being the initial reason for my work." Lanyon, interview by Crawford, 5 December 1975.

STATEMENT

ELLEN LANYON

I HAVE ALWAYS UTILIZED REALISM TO ENHANCE THE "UNREALISM" I WISH TO DESCRIBE. Since narrative is an essential element in my work, the challenge is to make the medium as eloquent as the image.

Source material is also central to my process, as I rely upon a method of seek and find (the source) for motivation. Generally, I begin to work by choosing an object and/or a theme and then, by making use of a so-called stream of consciousness approach, I allow the addition and juxtaposition of other, sometimes disassociated, elements to become a part of the narrative. Photographs, my own photo-documentation, nature guides, diverse ephemera, taxidermy, and many eccentric objects constitute my inanimate inspiration, while living flora and fauna and facets of the human condition (often portrayed by hands that can manipulate or control) provide the animate stimulus for my rather conglomerate imagery.

An awareness of the amazing phenomenon of life as it manifests itself through cause and effect motivates my ideas, often making the results seem to be a studied surrealism or a metaphysical remark. Perhaps so, but my initial concept is to translate the magical process of the metamorphosis that occurs once life begins. In doing so, I hope to create a visual text that can extend beyond my own interpretation and invite audience participation in the transformations and unfoldings. Thus, I attempt to present a two-dimensional theatric, one that will offer a symbolic narrative to be deciphered by the viewer. *Strange Games, The Mystery Explained,* and *Evidence of Life* are titles given to allow a clue to their metaphoric content.

The most recent series, *Homage à Poyet,* was inspired by the numerous illustrations of inventive machinery and magic by Louis Poyet, a nineteenth-century French engraver. Through the introduction of tools and other pseudo-inventions, these paintings attempt to expand upon the theme of the ever-advancing human imprint on the natural world. These devices seem innocent enough, but there is the implication of their power over nature. They are symbolic of the persistence of invention and the threat, rather than the benefit, they tend to promise.

ACKNOWLEDGMENTS

SUSAN FISHER STERLING, CHIEF CURATOR

Ellen Lanyon: Transformations, Selected Works from 1971-1999 AND THE ACCOMPANYING CATALOGUE ARE THE RESULT OF COOPERATION AND ASSISTANCE FROM A COMMITTED GROUP OF COLLECTORS AND ADMIRERS. We would like to express our appreciation to the artist and the following individuals and institutions for lending many of the finest examples of her work to the exhibition: Jean Albano Gallery; the Bergman Family Foundation; Mr. John Cain; Mr. Donald Ercole; Mr. Robert Fitzpatrick, Director, Museum of Contemporary Art, Chicago; Mr. Andrew Ginzel; Ms. Lisa Ginzel; Mr. Roland Ginzel; Ms. Krystin Grenon; Ms. Kristin Jones; Ms. Barbara Klawans; Landfall Press; Pondside Press; Printworks Gallery; and Mr. James N. Wood, Director, Art Institute of Chicago. In addition, we would like to thank the artist for providing us with a selection of the boxes, fans, taxidermic and porcelain animals, magic props, and mechanical devices featured in her art. These objects add another level of interest as we compare them to their beautifully rendered and reanimated counterparts in the paintings and drawings. As for the catalogue, we also extend our thanks to Debra Bricker Balken for her essay on Lanyon's compelling artistic and philosophical interest in the surrealism of life. We also acknowledge the important contributions of catalogue designer Alan Hill, and publisher Charles Gillett of The Studley Press, Dalton, Massachusetts.

The exhibition is also made possible through the generous support of Joanne and James Alter; the Bergman Family Charitable Trust; Patricia and Laurence Booth; Jean Albano Broday; Ms. Susan H. Caldwell; the Max and Victoria Dreyfus Foundation; The Richard Florsheim Art Fund; the Marshall Frankel Foundation; Gelick Associates Incorporated; Ms. Ruth Horwich; Angela and George Jacobi; Ms. Blanche Koffler; Ruth and Peyton Muehlmeier; Ms. Muriel K. Newman; Printworks Gallery; Sarajean and David C. Ruttenberg; Marlene and Shelly Stillman; and the members of NMWA.

Finally, we would like to express our deepest gratitude to Ellen Lanyon, whose thoughtful commentary and tireless devotion to this exhibition has made every aspect of its planning a pleasure as well as a beauty to behold.

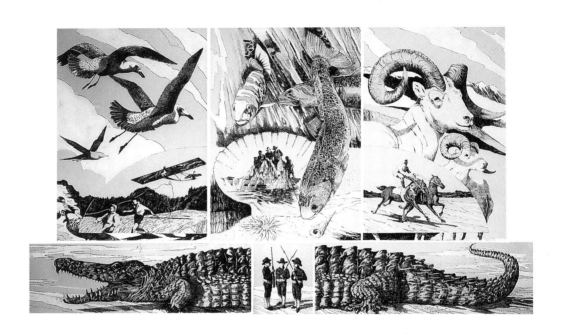

PLATE 27
THE ELEMENTS, *1991*
60 X 90 IN., *lithograph with colored pencil and watercolor*

46

ELLEN LANYON *Biography*

SELECTED SOLO EXHIBITIONS:

1999 Jean Albano Gallery, Chicago, IL
Printworks Gallery, Chicago, IL
Ellen Lanyon: Transformations, Selected Works from 1971–1999, The National Museum of Women in the Arts, Washington, DC, (catalogue)

1997 Andre Zarre Gallery, New York, NY
Jean Albano Gallery, Chicago, IL
Centro Cultural Costarricense Norteamericano, San Jose, Costa Rica

1996 TBA Space, Chicago, IL

1994 Andre Zarre Gallery, New York, NY
University of Iowa Museum of Art, Iowa City, IA

1993 Printworks Gallery, Chicago, IL
Struve Gallery, Chicago, IL

1992 Berland-Hall Gallery, New York, NY
Sioux City Art Center, Sioux City, IA

1990 *Works on Paper 1960–90,* Struve Gallery, Chicago, IL

1989 Printworks Ltd., Chicago, IL
Julian Pretto/Berland Hall Gallery, New York, NY

1987 *Ellen Lanyon, Strange Games: A Twenty-five Year Retrospective,* Chicago Cultural Center, Chicago, IL; Stamford Museum, Stamford, CT; Ewing Gallery, University of Tennessee, Knoxville, TN; Krannert Art Museum, University of Illinois, Urbana-Champaign, IL; Marion Koogler McNay Art Museum, San Antonio, TX, (catalogue) (through 1988)

1985 Richard Gray Gallery, Chicago, IL

1983 Susan Caldwell Inc., New York, NY
N.A.M.E. Gallery, Chicago, IL, (catalogue)

1982 Richard Gray Gallery, Chicago, IL
Zimmerli Art Museum, Rutgers University, New Brunswick, NJ

1981 Alverno College, Milwaukee, WI

1980 Nelson Gallery, University of California, Davis, CA
Landfall Press, Chicago, IL
Odyssia Gallery, New York, NY

1979 Richard Gray Gallery, Chicago, IL
Bradley University, Peoria, IL

1978 Fendrick Gallery, Washington, DC
Blaffer Gallery, University of Houston, Houston, TX
Northern Illinois University, Dekalb, IL

1977 Women's Building, Los Angeles, CA

1976 Galleria Odyssia, Rome, Italy (catalogue)
Harcus Krakow Rosen Sonnabend Gallery, Boston, MA
Krannert Performing Arts Center, University of Illinois, Urbana-Champaign, IL
University of Missouri, Kansas City, MO
Richard Gray Gallery, Chicago, IL

1974 John Michael Kohler Arts Center, Sheyboygan, WI
Nelson Gallery, University of California, Davis, CA
Pennsylvania State University, University Park, PA

1973	Richard Gray Gallery, Chicago, IL
1972	Zabriskie Gallery, New York, NY
	Madison Art Center, Madison, WI (catalogue)
	National Collection of Fine Arts, Washington, DC
1970	Richard Gray Gallery, Chicago, IL
1969	Zabriskie Gallery, New York, NY
1968	B. C. Holland Gallery, Chicago, IL
1967	Fort Wayne Art Museum, Fort Wayne, IN (catalogue)
1965	B. C. Holland Gallery, Chicago, IL
1964	Zabriskie Gallery, New York, NY
1963	Haydon Calhoun Gallery, Houston, TX
1962	Stewart Rickard Gallery, San Antonio, TX
	Fairweather Hardin Gallery, Chicago, IL
	Zabriskie Gallery, New York, NY
1958	Superior Street Gallery, Chicago, IL
1948	Carlebach Gallery, New York, NY

SELECTED GROUP EXHIBITIONS:

1999	(Un)becoming, Jean Albano Gallery, Chicago, IL
	The 174th Annual Exhibition, National Academy, New York, NY (catalogue)
	Contemporary Classicism, Neuberger Museum of Art, Purchase, NY (catalogue)
	Primary Colors, Jean Albano Gallery, Chicago, IL
1998	Collaborations, Printworks Gallery, Chicago, IL
	The Joe Wilfer Show, Plattsburgh Art Museum, Plattsburgh, NY (catalogue)
1997	Selections from the Collection, Krannert Museum, University of Illinois, Urbana-Champaign, IL
	Silver and Gold, Jean Albano Gallery, Chicago, IL
	Game of Chance, Printworks Gallery, Chicago, IL
	Eleven for Ninety Seven, Andre Zarre Gallery, New York, NY
	Landfall Press: Twenty-five Years of Printmaking, Milwaukee Art Museum, Milwaukee, WI; Chicago Cultural Center, Chicago, IL (catalogue)
1996	Second Sight: Modern Printmaking in Chicago, Block Gallery, Northwestern University, Evanston, IL (catalogue)
	Women and Chicago Imagism, Rockford Art Museum, Rockford IL; Illinois Art Gallery, Chicago, IL, (catalogue)
	Julien Pretto Collection, Wadsworth Atheneum, Hartford, CT
	Modern Fable, Andre Zarre Gallery, New York, NY
	Generations: Chicago Printers and Printmakers, Suburban Fine Arts Center, Highland Park, IL
	Art in Chicago: 1945–1995, Museum of Contemporary Art, Chicago, IL (catalogue)
	Self-Portraits 1996, Printworks Gallery, Chicago, IL
1995	Lucy Lippard Collection, Bard College, Rhinebeck, NY
	Selections from the Toni Gutfreund Collection, Oakton College, Des Plaines, IL
	Book as Art VII, The National Museum of Women in the Arts, Washington, DC (catalogue)
	Twentieth Anniversary Exhibition, Andre Zarre Gallery, New York, NY
1994	The Peaceable Kingdom, Babcock Gallery, New York, NY
	Fifty-fifth Anniversary Invitational, Hyde Park Art Center, Chicago, IL
	The Aesthetics of Athletics, Wutsum Museum of Fine Arts, Racine, IL

Artists' Sketchbooks: The Intimate Journeys, The National Museum of Women in the Arts, Washington, DC, (catalogue)

1993 *Through Thick and Thin*, Andre Zarre Gallery, New York, NY

Songs of Retribution, Richard Anderson Gallery, New York, NY

1992 *Landscape as Stage*, Marian Locks Gallery, Philadelphia, PA (catalogue)

From America's Studio: Drawing New Conclusions, School of the Art Institute of Chicago, Chicago, IL (catalogue)

Face to Face: Self Portraits by Chicago Artists, Cultural Center, Chicago, IL (catalogue)

1991 Berland Hall Gallery, New York, NY

Printworks Ltd., Chicago, IL

Solo Press Gallery, New York, NY

Randall Gallery, St. Louis, MO

Burning in Hell, Franklin Furnace, New York, NY

1990 *Group Exhibition*, Julian Pretto/Berland Hall, New York, NY

For the Birds, Wustum Museum of Fine Arts, Racine, WI (catalogue)

Recent Acquisitions, Prints and Drawings, Art Institute, Chicago, IL

1989 *Lines of Vision: Drawings by Contemporary Women*, traveling exhibit: United States and South America (catalogue)

A Critical Subject: Portraits of Dennis Adrian, Struve Gallery, Chicago, IL

Symbolism, Cooper Union Gallery, New York, NY, curator: Lenore Malen (catalogue)

Coming of Age, Madison Art Center, Madison, WI (catalogue)

1988 *One Hundred Women's Drawings*, Hillwood Gallery, C. W. Post, Long Island University, Greenvale, NY

Collage at N.A.M.E., N.A.M.E. Gallery, Chicago, IL

The Legacy of Surrealism in American Art, Ben Shahn Gallery, William Paterson College, Wayne, NJ (catalogue)

American Herstory: Women and the U.S. Constitution, Atlanta College of Art, Atlanta, GA (catalogue)

Hothouse, John Michael Kohler Arts Center, Sheboygan, WI

Alice, and Look Who Else, through the Looking Glass, Steinbaum Gallery, New York, NY, traveling exhibition (catalogue)

Realism Today: The Rita Rich Collection, National Academy of Design, New York, NY; Museum of Art, Smith College, Northampton, MA; Arkansas Art Center, Little Rock, AR; Butler Institute of American Art, Youngstown, OH (catalogue)

1987 *Made in the U.S.A.: Art from the 50s and 60s*, University Art Museum, Berkeley, CA; Virginia Museum of Fine Arts, Richmond, VA (catalogue)

Retrospective Print Exhibition: Berdich, Golub, Lanyon, Printworks Ltd., Chicago, IL

1986 *Contemporary Screens*, Contemporary Art Center, Cincinnati, OH; Lowe Art Museum, University of Miami, Coral Gables, FL; City Gallery of Contemporary Art, Raleigh, NC; Toledo Museum of Art, Toledo, OH; Des Moines Art Center, Des Moines, IA (catalogue)

Artists Source, traveling exhibition (catalogue)

Monumental Space Variations, One Penn Plaza, New York, NY (catalogue)

Big Containment, Northern Illinois University, Dekalb, IL

1985 *The Figure and the Landscape*, Artists Choice Museum, New York, NY (catalogue)

Small Works, Bank of Boston, Boston, MA, (catalogue)

Silhouette, Allan Frumkin Gallery, New York, NY

The Baseball Card Portrait Show, Renaissance Society, University of Chicago, Chicago, IL

Art on Paper, Weatherspoon Art Gallery, University of North Carolina, Greensboro, NC (catalogue)

American Art, American Women, Stamford Museum, Stamford, CT (catalogue)

Art, Design and the Modern Corporation, National Museum of American Art, Washington, DC (catalogue)

The Folding Image, Yale University, New Haven, CT; National Gallery of Art, Washington, DC (catalogue)

American Realism: Glenn C. Janss Collection, San Francisco Museum of Modern Art, San Francisco, CA; National Academy of Design, New York, NY (catalogue)

Summer Exhibition, Krannert Art Museum University of Illinois, Urbana, IL

1984 *De Libros de Artistas*, Bienale Internacionale,
C.A.Y.C., Buenos Aires, Argentina
Offset: A Survey of Artists Books, Hera Foundation,
traveling exhibition
Animals, Animals, Stamford Museum, Stamford,
CT (catalogue)
Collectors Gallery XVII, Marion Koogler McNay
Art Institute, San Antonio, TX
Painting and Sculpture Today, Indianapolis
Museum of Art, Indianapolis, IN (catalogue)
Selections from the Permanent Collection, Museum of
Contemporary Art, Chicago, IL
The Illinois Collection, Richard Gray Collection,
Chicago, IL
Images on Paper, Art 7 Architecture Gallery,
University of Tennessee, Knoxville, TN
(catalogue)
A New Look at American Landscape, Frumkin &
Struve Gallery, Chicago, IL
Alternative Spaces, Museum of Contemporary Art,
Chicago, IL (catalogue)
Landfall Press Publications, Landfall Press,
Chicago, IL

1983 *The Artist and the Quilt*, traveling exhibition
(catalogue)
Twentieth Century American Watercolors, traveling
exhibition (catalogue)
Fans, Hyde Park Art Center, Chicago, IL

1982 *International Artists Book Invitational*, Buenos Aires,
Argentina
Multiples, Art Institute, Chicago, IL; National
Institute of Design, New York, NY; National
Museum of American Art, Washington, DC;
Portland Art Museum, Portland, OR
(catalogue)
Windows, Room, Furniture, Cooper Union, New
York, NY (catalogue)
*Realism and Realities: The Other Side of American
Painting*, Jane Voorhees Zimmerli Art Museum,
Rutgers University, New Brunswick,
NJ (catalogue)
Selections from the Dennis Adrian Collection, Museum
of Contemporary Art, Chicago, IL (catalogue)
American Prints 1960–1980, Milwaukee Art
Museum, Milwaukee, WI
Summer Invitational Exhibition, Susan Caldwell
Gallery, New York, NY

1981 *The American Landscape: Recent Developments*,
Whitney Museum, Fairfield, CT (catalogue)

Carnevale del Teatro, Biennale di Venezia, Venice,
Italy
Words and Images, Pittsburgh Center for the Arts,
Pittsburgh, PA (catalogue)
Re-Pages, New England Foundation for the Arts,
Boston, MA, traveling exhibition (catalogue)
New Dimensions in Drawing, Aldrich Museum of
Contemporary Art, Ridgefield, CT (catalogue)

1980 *LIS '80, Lisbon International Invitational*, Lisbon,
Portugal (catalogue)
Prizewinners Revisited, Art Institute, Chicago, IL
Fire and Water, Ridgefield Center for the Arts,
Ridgefield, CT (catalogue)
Mysterious and Magical Realism, Aldrich Museum of
Contemporary Art, Ridgefield, CT (catalogue)
Black and White Drawings Invitational, Brooklyn
Museum of Art, Brooklyn, NY (catalogue)

1979 *The Pastel in America*, Odyssia Gallery,
New York, NY (catalogue)
Self Portraits, Madison Art Center, Madison, WI
The Watercolor Still Life, Gladstone Villani Gallery,
New York, NY
The George Irwin Collection, Krannert Art
Museum, University of Illinois, Urbana-
Champaign, IL
One Hundred Artists, One Hundred Years, Art
Institute, Chicago, IL (catalogue)

1978 *Chicago: The City and Its Artists 1945–1978*,
University of Michigan, Ann Arbor, MI
(catalogue)
Great Ideas, Collection of the Container
Corporation of America, Chicago Cultural
Center, Chicago, IL (catalogue)
Book Forms, Dayton Art Institute, Dayton, OH
(catalogue)
Sports, Queens Museum, Flushing, NY

1977 *Artists Choice: Figurative Art in New York*, Green
Mountain Gallery, New York, NY (catalogue)
Figurative Painting in the Midwest, Madison Art
Center, Madison, WI (catalogue)
Private Images: Photographs by Painters, Los Angeles
County Museum of Art, Los Angeles,
CA (catalogue)
Contemporary Women: Consciousness and Content,
Brooklyn Museum, Brooklyn, NY
Recent Works on Paper, Madison Art Center,
Madison, WI (catalogue)
Masterpieces of Chicago Art, Chicago Cultural
Center, Chicago IL

Out of the House, Whitney Museum—Downtown, New York, NY

1976 *The Book as Art*, Fendrick Gallery, Washington, DC

Landscape Art in Illinois 1830–1976, Illinois Arts Council, Chicago, IL, traveling exhibition (catalogue)

American Artists '76, Marion Koogler McNay Art Institute, San Antonio, TX

Hyde Park Art Center Retrospective, H.Y.P.C., Chicago, IL (catalogue)

America '76, U. S. Department of Interior, Bicentennial traveling exhibition (catalogue)

Chicago Connection, E. B. Crocker Art Gallery, Sacramento, CA, traveling exhibition (catalogue)

Society for Contemporary Art, Art Institute, Chicago, IL (also 1971/64/55/52)

1975 *Foodstuff*, John Michael Kohler Arts Center, Sheboygan, WI (catalogue)

American Women Printmakers, University of Missouri, St. Louis, MO

1974 *Still Life*, Renaissance Society, University of Chicago, Chicago, IL (catalogue)

Art on Paper, Weatherspoon Art Gallery, University of North Carolina, Greensboro, NC (catalogue)

1973 *Artists' Books*, Moore College, Philadelphia, PA

Chicago Style, Renaissance Society, University of Chicago, Chicago, IL

National Drawing Invitational, Krannert Art Museum, University of Illinois, Urbana-Champaign, IL

Landfall Press Prints, Smithsonian Institution, Washington, DC, traveling exhibition (catalogue)

Una Tendenza Americana, Galleria Communale D'Arte, Arezzo, Italy, traveling exhibition (catalogue)

Annual Exhibition, Illinois State Museum, Springfield, IL (also 1969/68/65)

1972 *Chicago Imagists*, Museum of Contemporary Art, Chicago, IL; New York Cultural Center, New York, NY (catalogue)

American Women Twentieth Century, Lakeview Center, Peoria, IL (catalogue)

Unmanly Art, Suffolk Museum, Stony Brook, NY (catalogue)

1971 *National Drawing Invitational*, Southern Illinois University, Carbondale, IL, (catalogue)

Society for Contemporary Art, Art Institute, Chicago, IL (also 1964/55/52)

Each in His Own Way, FTD Corporation, Downers Grove, IL, traveling exhibition (catalogue)

1970 *Acquisitions*, University of Massachusetts, Amherst, MA

Birds and Beasts, Graham Gallery, New York, NY (catalogue)

1968 *Response, Artists' Protest Exhibition*, Chicago, IL

Violence, Museum of Contemporary Art, Chicago, IL (catalogue)

Nostalgia, American Federation of Arts, New York, NY, traveling exhibition (through 1969)

Illinois Painters, Illinois Arts Council, Chicago, IL, traveling exhibition (catalogue) (through 1971)

1967 *L.B.J. Exhibition*, Richard Gray Gallery, Chicago, IL

1965 *Drawing Society Invitational*, Dallas Art Museum, Dallas, TX

Stewart Rickard Gallery, San Antonio, TX

The Drawing Society National Exhibition, Museum of Fine Arts, Houston, TX

Art in Process, Finch College, New York, NY (catalogue)

Fourteen Illinois Artists, Illinois Arts Council, traveling exhibition (catalogue)

1963 *Recent Paintings USA: The Figure*, Museum of Modern Art, New York, NY (catalogue)

1961 *Twenty-seventh Biennial Exhibition*, Corcoran Gallery of Art, Washington, DC (catalogue)

1958 *Chicago Painters*, Stuart Brent Gallery, Chicago, IL

Superior Street Gallery, Chicago, IL (through 1961)

1957 *Modern Paintings of Chicago*, Art Institute, Chicago, IL, traveling exhibition: France & Germany (catalogue) (through 1957)

Summer Painting Show, University of Iowa, Iowa City, IA

Chicago Painters, Stuart Brent Gallery, Chicago, IL

1955 *Chicago Graphic Workshop Exhibition*, Art Institute, Chicago, IL

Fifty American Printmakers, University of Wisconsin, Madison, WI

1954 *Chicago Artists*, Downtown Gallery, New York, NY

Northwest Printmakers, Seattle Art Museum, Seattle, WA

Graphics USA, Krannert Art Museum, University of Illinois, Urbana-Champaign, IL (catalogue)

Print Annual, Philadelphia Museum of Art, Philadelphia, PA (also 1950/47/45)

1953　　*American Biennale*, Art Institute, Chicago, IL
　　　　(catalogue) (also 1951/47/45)
　　　　Contemporary American Painting, Krannert Art
　　　　　Museum, University of Illinois, Urbana-
　　　　　Champaign, IL (catalogue) (through 1957)
　　　　Young Printmakers, Museum of Modern Art,
　　　　　New York, NY (catalogue)

1952　　*Print, Drawing and Watercolor Exhibition*,
　　　　　Metropolitan Museum of Art, New York, NY
　　　　Printmaking Annual, Denver Art Musem, Denver,
　　　　　CO (also 1950)

1950　　*National Juried Exhibition*, San Francisco Museum
　　　　　of Art, San Francisco, CA (also 1945)
　　　　Print Annual, Library of Congress, Washington, DC
　　　　Iowa Print Group Exhibition, London County
　　　　　Council, London, England
　　　　Print Annual, Joslyn Museum of Art, Omaha, NE
　　　　Annual Exhibition, Des Moines Art Center,
　　　　　Des Moines, IA (catalogue)

1948　　Carlebach Gallery, New York, NY
　　　　Exhibition Momentum, Roosevelt University,
　　　　　Chicago, IL (catalogue) (also 1951–55)

1945　　American Federation of Arts, New York, NY,
　　　　　traveling exhibitions (catalogues) (through
　　　　　1969)

1945　　Chicago and Vicinity Annuals, Art Institute,
　　　　　Chicago, IL (catalogues) (through 1982)

SELECTED COMMISSIONS:

1999　　Riverwalk Gateway Ceramic Mural Project,
　　　　　Dept. of Cultural Affairs and Dept. of
　　　　　Transportation, Chicago, IL
　　　　Finalist, U.S. Dept. of the Interior, Mural
　　　　　Project

1997　　National Museum of Women in the Arts, Print
　　　　　Portfolio, Gresham Studio, Ltd., Cambridge,
　　　　　England

1996　　Electric Wave City Bus Project, Transportation
　　　　　Management Association, Miami Beach, FL

1992　　Art in Public Places Mural Commission,
　　　　　Police & Court Facility, Miami Beach, FL

1989　　*The Rise of Chicago* (mural), Illinois Capitol
　　　　　Centennial Project, main concourse, State
　　　　　Capitol Building, Springfield, IL

1985　　*Survival* (mural), State of Illinois Building,
　　　　　Helmut Jahn, architect, Chicago, IL
　　　　Falco (bronze vessel), Southern Illinois
　　　　　University, Carbondale, IL (Invitational
　　　　　Sculpture Workshop Project)

1980　　*Notable Women of Boston* (mural), Workingman's
　　　　　Cooperative Bank, Boston, MA

1975　　*Great Ideas* (painting series), Container Corp. of
　　　　　America, Chicago, IL
　　　　Everglades (painting), U.S. Dept. of the Interior
　　　　　Bicentennial Traveling Exhibition (catalogue)
　　　　Keepsake (painting), Northern Indiana
　　　　　Bicentennial Project
　　　　Thirteen Drawings, Grimaldi Collection, Rome,
　　　　　Italy

1973　　*Nine Chicago Artists Box* (sculpture), Museum of
　　　　　Contemporary Art, Chicago, IL

1971　　Painting, Illinois Bell Telephone Company,
　　　　　Chicago, IL

1970　　*Each in His Own Way* (painting), FTD
　　　　　Corporation, Downers Grove, IL, traveling
　　　　　exhibition

1968　　*Ostricart* (lithograph), Ravinia Festival Association
　　　　　Annual Commemorative Print, Ravinia Park,
　　　　　Highland Park, IL

SELECTED GRANTS & AWARDS:

1998	Florsheim Foundation Grant
	Yaddo Fellowship, Saratoga Springs, NY
	(also 1976/75/74)
1997	Elected to the National Academy, New York, NY
1987	National Endowment for the Arts,
	Artists Grant in Painting (also 1974)
1982	Logan Prize, Art Institute, Chicago, IL
1981	Herewood Lester Cook Foundation Grant,
	Washington, DC
1976	Ossabaw Island Project, Ossabaw Island, GA
1974	Honorary B.F.A., Graduation Address, Chicago
	Academy of Fine Arts, Chicago, IL
1971	Cassandra Foundation, Artists Grant
1950	Fulbright Scholarship, Courtauld Institute,
	University of London, London, England
	(also 1951)

SELECTED PUBLIC COLLECTIONS:

Adrian College, Adrian, MI
Albion College, Albion, MI
Art Institute of Chicago, Chicago, IL
Boston Public Library, Boston, MA
Brooklyn Museum, Brooklyn, NY
Chicago Public Library, Chicago, IL
City of Chicago, Riverwalk Gateway Project, Chicago, IL
City of Miami Beach, Police & Court Facility,
 Miami Beach, FL
Cleveland Center for the Arts, Cleveland, OH
Cornell University, Ithaca, NY
CUNY Performing Arts Center, York College,
 Queens, NY
Denver Art Museum, Denver, CO
Des Moines Art Center, Des Moines, IA
Galleria Comunale D'Arte Contemporanea, Arezzo, Italy
Illinois State Museum, Springfield, IL
Illinois Wesleyan University, Peoria, IL
Institute of International Education, London, England
Kansas State University, Manhattan, KS
Krannert Museum, University of Illinois,
 Urbana-Champaign, IL
Library of Congress, Washington, DC
Madison Art Center, Madison, WI
Marion Koogler McNay Art Institute, San Antonio, TX
Metropolitan Museum of Art, New York, NY
Milwaukee Art Museum, Milwaukee, WI
Museum of Contemporary Art, Chicago, IL
National Museum of American Art, Washington, DC
National Museum of Women in the Arts, Washington, DC
New Jersey State Museum, Trenton, NJ
New York Public Library, New York, NY
Palm Springs Museum, Palm Springs, CA
State Capitol, Springfield, IL
State of Illinois Building, Chicago, IL
State University of Iowa, Iowa City, IA
University of California, Davis,
 Richard L. Nelson Gallery
University of Dallas, Dallas, TX
University of Houston, Houston, TX
University of Illinois Medical Center, Chicago, IL
University of Massachusetts, Andover, MA
University of Notre Dame, South Bend, IN
University of Oklahoma, Norman, OK
Wadsworth Atheneum, Hartford, CT
Walker Art Center, Minneapolis, MN

SELECTED PUBLISHED PRINTS:

1998 *Red Alert*, etching, publisher: Anchor Press, Chicago, IL

1997 *Beyond the Borders*, six-color lithograph, publisher: Anchor Press, Chicago, IL

Naumkeag, nine-color serigraph, publisher: Gresham Studio, Ltd., Cambridge, England

1991 *The Elements*, suite of four one-color lithographs/hand colored, publisher: Pondside Press, Rhinebeck, NY

1989 *Survival of the Fittest*, four-color lithograph, publisher: Pondside Press, New York, NY

Niagara, seven-color lithograph, publisher: Solo Press, New York, NY

1987 *Encore Events (Vanish Extraordinary)*, linecut/handmade paper, publisher: Joe Wilfer, Upper U.S. Papermill, Madison, WI

Perch Parrocide, linecut, publisher: Joe Wilfer, Upper U.S. Papermill, Madison, WI

1985 *Eaglebeak* and *Black Egret*, lithographs, publisher: Landfall Press, Chicago, IL

1984 *Illinois*, lithograph, publisher: Four Brothers Press, Chicago, IL

1983 *Transformations II (Endangered)*, publisher: Chicago Books, New York, NY

1982 *Chicago T*, two-color lithograph for Chicago Trust, publisher: Four Brothers Press, Chicago, IL

Drawings for *The Sacher Torte*, author: Diane Wakoski, publisher: Perishable Press, Mount Horeb, WI

Drawings for *The Weasel*, author: Annie Dillard, publisher: Rara Avis Press, Chicago, IL

1981 *The Mystery Explained (Nymphaea Alba)*, four-color lithograph, publisher: Six H.C., University of South Dakota, Vermillion, SD

The Mystery Explained (Bognonia Capreolata), four-color lithograph, publisher: Oxbow Press, Saugatuck, MI

The Mystery Explained (Hemerocallis Flava), four-color lithograph, publisher: Four Brothers Press, Chicago, IL

Drawings for *The Managed World*, author: Diane Wakoski, publisher: Red Ozier Press, Chicago, IL

1980 Drawing for *The Mirabai Version*, author: Robert Bly, publisher: Red Ozier Press, Chicago, IL

Strange Games A–B–C–D, suite of four one-color lithographs/hand colored, publisher: Landfall Press, Chicago, IL

1979 *Six Episodes*, publisher: Landfall Press, Chicago, IL

1977 *Transformation I*, publisher: Printed Matter, New York, NY

Zed, four-color lithograph, publisher: University of Houston, Houston, TX

1977 Drawings for *Chrysalis Magazine,* Los Angeles, CA

1976 *Everglades Fan*, two-color lithograph, publisher: Stone Roller Press, Chicago, IL

Everglades, one-color lithograph, publisher: Stone Roller Press, Chicago, IL

Hermit Crab, one-color lithograph, publisher: Stone Roller Press, Chicago, IL

1975 *Madison Fan*, die-cut linocut, publisher: Madison Print Club Annual Publication, Madison, WI

Drawings for *Jataka Tales*, author: Nancy de Roin, publisher: Houghton Mifflin, Boston, MA

Drawings for *The Wandering Tattler*, author: Diane Wakoski, publisher: Perishable Press, Mount Horeb, WI

1973 *Thimblebox*, four-color lithograph, publisher: Landfall Press, Richard Gray Gallery, Chicago, IL

Cockatoo Clock, lithograph, publisher: School of the Art Institute of Chicago, Chicago, IL

Drawings for *Two Stories*, author: Kenneth Bernard, publisher: Perishable Press, Mount Horeb, WI

1972 Drawings for *In Sight of Blue Mounds*, author: Walter Hamady, publisher: Perishable Press, Mount Horeb, WI

Drawings for *The Life of Parts . . .*, author: Robert Vas Dias, publisher: Perishable Press, Mount Horeb, WI

Drawings for *The Owl and the Snake*, author: Diane Wakoski, publisher: Perishable Press, Mount Horeb, WI

1971 *Wonder Production Volume I*, publisher: Libre delux, Landfall Press, Chicago, IL

SELECTED CATALOGUES:

1999 *Ellen Lanyon: Transformations, Selected Works from 1971–1999*, The National Museum of Women in the Arts, Washington, DC; essay by Debra Bricker Balken

Contemporary Classicism, Neuberger Museum of Art, Purchase, NY; essay by Judy Collischan

1998 *The Joe Wilfer Show*, Plattsburg Art Museum, Plattsburg, NY

1997 *Landfall Press, Twenty-five Years of Printmaking*, Milwaukee Art Museum, Milwaukee WI; essay by Joseph Ruzicka

Women and Chicago Imagism, Rockford Art Museum, Rockford, IL; State of Illinois Art Gallery, Chicago, IL; essay by Scott Snyder

1996 *Second Sight: Modern Printmaking in Chicago*, Block Gallery, Northwestern University, Evanston, IL; essays by Mark Pascale, James Yood, and David Mickenberg

Art in Chicago: 1945–1995, Museum of Contemporary Art, Chicago, IL; essays by Abell, Adrian, Boris, Corbett, Horsfield, Jaffe, Kirshner, Rago, Schulze, Selz, Stamets, and Warren

1995 *Book as Art VII*, National Museum of Women in the Arts, Washington, DC; essay by Krystyna Wasserman

1994 *Artists' Sketchbooks*, National Museum of Women in the Arts, Washington, DC; essay by Krystyna Wasserman

1992 *Ellen Lanyon*, Berland-Hall Gallery, New York, NY; essay by Eleanor Heartney

Landscape as Stage, Locks Gallery, Philadelphia, PA; essay by M. Raphael Rubinstein

Face to Face, Chicago Cultural Center, Chicago, IL; essay by Greg Knight

From America's Studio: Drawing New Conclusions, School of the Art Institute of Chicago, Chicago, IL; essay by James Yood

1990 *For the Birds*, Wustum Museum of Fine Arts, Racine, WI

1989 *Lines of Vision: Drawings by Contemporary Women*, Hillwood Art Museum, Long Island Univ., Brookville, NY; essay by Judy K. Collischan

Symbolism, Cooper Union Gallery, New York, NY

Coming of Age, Madison Art Center, Madison, WI

1988 *The Legacy of Surrealism in American Art*, William Patterson College, Wayne, NJ

American Herstory: Women and the U.S. Constitution, Atlanta College of Art, Atlanta, GA; essay by Eleanor Tufts

Realism Today: The Rita Rich Collection, National Academy of Design, New York, NY; essay by John I. H. Bauer

Alice, and Look Who Else, through the Looking Glass, Steinbaum Gallery, New York, NY; essay by John Perreault

1987 *Made in the USA: Art from the 50s and 60s*, University of California, Berkeley, CA; essay by Sidra Stich

Models, Maquettes and Studies, Illinois State Museum, Springfield, IL; essay by Michael Dunbar

Ellen Lanyon, Strange Games: A Twenty-five Year Retrospective Exhibition, Krannert Museum, University of Illinois, Urbana-Champaign, IL; esssay by Donald Kuspit

1986 *Contemporary Screens*, Art Museum Association; essay by Virginia Butera

Artist Source, School of the Art Institute, Chicago, IL; essay by Dan Mills

Monumental Space Variations, One Penn Plaza, New York, NY; essay by Donald Kuspit

1985 *American Realism: Glenn C. Jans Collection*, San Francisco Museum of Modern Art, San Francisco, CA; foreword by Henry T. Hopkins, essay by Alvin Martin

The Folding Image, Yale University Art Museum, New Haven, CT; National Gallery of Art, Washington, DC; introduction by Janet W. Adams, essays by Michael Komanecky and Virginia Butera

Art, Design, and the Modern Corporation, National Museum of American Art, Washington, DC

American Art, American Women, Stamford Art Museum, Stamford, CT; essay by Dorothy Mayhall

Art on Paper, Weatherspoon Gallery, University of North Carolina, Greensboro, NC; essay by Donald Droll

Small Works, Bank of Boston, Boston, MA; essay by John Arthur

1984 *Painting and Sculpture Today*, Indianapolis Museum of Art, Indianapolis, IN; essay by Helen Ferrulli

Alternative Spaces, Museum of Contemporary Art, Chicago, IL; essay by Lynn Warren

Animals, Animals, Stamford Art Museum and

Nature Center, Stamford, CT; essay by
Dorothy Mayhall

Images on Paper, University of Tennessee,
Knoxville, TN; essays by Sam Yates and
Don Kurka

Offset, A Survey of Artists Books, Hera Foundation

1983 *Ellen Lanyon*, N.A.M.E. Gallery, Chicago, IL;
essays by Lucy Lippard and Dennis Adrian

Continuity and Change, Artist Independent
Exhibition, Chicago, IL

Twentieth Century American Watercolor, Independent
Curators, New York, NY; essay by Janice
Oresman

The Artist and the Quilt, traveling exhibition; essay
by Eleanor Munroe

1982 *Window, Room, Furniture*, Cooper Union
/Rizzoli, New York, NY; essays by Todd
Williams and Richard Scofido

Multiples, Art Institute, Chicago, IL;
essay by Esther Sparks

*Realism and Realities: The Other Side of American
Painting*, Rutgers University, New Brunswick, NJ;
essays by Greta Berman and Jeffrey Wechsler

Selections from the Dennis Adrian Collection, Museum
of Contemporary Art, Chicago, IL

1981 *Re-Pages*, New England Foundation for the Arts,
Boston, MA; traveling book exhibition

New Dimensions in Drawing, Aldrich Museum of
Contemporary Art, Ridgefield, CT;
introduction by R. E. Anderson

Words and Images, Pittsburgh Center for the Arts,
Pittsburgh, PA

The American Landscape: Recent Developments,
Whitney Museum, Fairfield, CT

The Flower in American Art, Heritage Foundation,
Sandwich, MA

1980 *Black and White Drawings*, Brooklyn Museum,
Brooklyn, NY

Mysterious and Magical Realism, Aldrich Museum of
Contemporary Art; essay by Martin T. Sosnoff

Fire and Water, Ridgefield Center for the Arts,
Ridgefield, CT

LIS '80, Lisbon International Invitational, Lisbon,
Portugal; essay by Donald Kuspit

1979 *One Hundred Artists, One Hundred Years*, Art
Institute, Chicago, IL; essay by Katherine Kuh

The George Irwin Collection, Krannert Museum,
University of Illinois, Urbana-Champaign, IL;
essay by John Arthur

The Pastel in America, Odyssia Gallery, New York,
NY; essay by Irving Petlin

1978 *Book Forms*, Dayton Art Institute, Dayton, OH

Chicago: The City and Its Artists 1945–1978,
University of Michigan, Ann Arbor, MI; essay
by Barbara Tannenbaum

1977 *Recent Work on Paper*, Madison Art Center,
Madison, WI

Artists Choice: Figurative Art in New York, Green
Mountain Gallery, New York, NY; essay by
Lawrence Alloway

Figurative Painting in the Midwest, Madison Art
Center, Madison, WI

1976 *America '76*, U.S. Dept. of the Interior,
Bicentennial traveling exhibition; essay by
Robert Rosenblum

The Book as Art, Fendrick Gallery, Washington, DC

Galleria Odyssia, Rome, Italy; essay by Dennis
Adrian

Landscape Art in Illinois 1830–1976, Illinois Arts
Council, Chicago, IL, traveling exhibition

Chicago Connection, E. B. Crocker Art Gallery,
Sacramento, CA, traveling exhibition

1974 *Still Life*, Renaissance Society, University of
Chicago, Chicago, IL

Art on Paper, Weatherspoon Art Gallery,
University of North Carolina, Greensboro,
NC; essay by Donald Droll

1973 *National Drawing Invitational*, Krannert Museum,
University of Illinois, Urbana-Champaign, IL

Landfall Press Prints, Smithsonian traveling
exhibition

Una Tendenza Americana, Galleria Communale
D'Arte, Arezzo, Italy; essay by Luigi Carluccio

1972 *American Women Twentieth Century*, Lakeside Center,
Peoria, IL; essay by Ida Kohlmeyer

Chicago Imagists, Museum of Contemporary Art,
Chicago, IL; essay by Franz Schulze

Unmanly Art, Suffolk Museum, Stony Brook, NY;
essay by Lucy Lippard

1971 *Each in His Own Way*, FTD Corporation, Downers
Grove, IL, traveling exhibition; essays by Pierre
Restany and Jan Van Der Marck

National Drawing Invitational, Southern Illinois
University, Carbondale, IL

1970 *Birds and Beasts*, Graham Gallery, New York, NY;
essay by David Herbert

1968 *Violence*, Museum of Contemporary Art,
Chicago, IL; essay by Robin Glauber

1967 *Ellen Lanyon*, Fort Wayne Art Museum, Fort
 Wayne, IN; essay by Donn L. Young
1966 *The Painter and the Photograph*, University of New
 Mexico, Albuerqueque, NM; essay by
 Van Deren Coke
 Six Illinois Painters, Illinois Arts Council,
 Chicago, IL
1965 *Art in Process*, Finch College, New York, NY; essay
 by Elaine Varian
 Fourteen Illinois Artists, Illinois Arts Council,
 Chicago, IL
1963 *Recent Painting USA: The Figure*, Museum of
 Modern Art, New York, NY; essay by
 Alfred Barr Jr.
1961 *Corcoran Gallery Invitational, Twenty-seventh Biennial*,
 Corcoran Gallery of Art, Washington, DC;
 essay by Hermann Warner Jr.
1957 *Modern Paintings of Chicago*, Art Institute,
 Chicago, IL
 Contemporary American Painting, Krannert Museum,
 University of Illinois, Urbana-Champaign;
 essay by Allen S. Weller (also 1953)
1954 *Northwest Printmakers*, Seattle Art Museum,
 Seattle, WA
 Graphics USA, Krannert Museum, University of
 Illinois, Urbana-Champaign, IL
 Print Annual, Philadelphia Museum of Art,
 Philadelphia, PA (also 1950/47/45)
1953 *American Biennale*, Art Institute, Chicago, IL (also
 1951/47/45)
 Young Printmakers, Museum of Modern Art,
 New York, NY
1952 *Print, Drawing and Watercolor Exhibition*,
 Metropolitan Museum of Art, New York, NY
 Printmaking Annual, Denver Art Museum, Denver,
 CO (also 1950)
1950 *National Juried Exhibition*, San Francisco Museum
 of Art, San Francisco, CA (also 1945)
 Print Annual, Library of Congress, Washington, DC
 Print Annual, Joslyn Museum of Art, Omaha, NE
 Annual Exhibition, Des Moines Art Center, Des
 Moines, IA
1948 *Exhibition Momentum*, Roosevelt University,
 Chicago, IL (also 1951–55)
1945 *American Federation of Arts Traveling Exhibitions*
 (through 1969)
 Chicago and Vicinity Annual, Art Institute, Chicago,
 IL (through 1982)

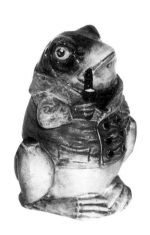

EXHIBITION *Checklist*

SILK CABBY, *1971*
Acrylic on canvas, three-panel screen
60 X 108 IN.
On loan from the artist

SUPER VANISH EXTRAORDINARY, *1972*
Graphite on handmade feather paper
21 X 16 IN.
Private collection

COCKATOO/SNAKE, *1972*
Graphite on handmade feather paper
21 X 16 IN.
Private collection

COCKATOO/CAGE, *1972*
Graphite on handmade feather paper
21 X 16 IN.
On loan from the artist

THE ITALIAN BOX, *1973*
Acrylic on canvas
42 X 32 IN.
On loan from the artist

COCKATOO CLOCK, *1973*
Acrylic on canvas
36 X 30 IN.
On loan from the Bergman Family Foundation

THIMBLEBOX, *1973*
Color lithograph on black paper
30 X 36 IN.
Publisher: Landfall Press and Richard Gray
On loan from the artist

COCKATOO MAGIC, *1974*
Colored pencil on black paper
30 X 40 IN.
On loan from the artist

THE DISGUISE, *1975*
Colored pencil on black paper
36 X 30 IN.
Private collection

MRAZEK POND, *1975*
Acrylic on canvas
36 X 46 IN.
On loan from Lisa Ginzel

TRANSFORMATIONS, *1975*
Color lithograph with colored pencil on black paper
20 X 30 IN.
On loan from Krystin Grenon

EVERGLADES, *1976*
Lithograph and watercolor
30 X 22 IN.
Publisher: Stone Roller Press
Private collection

HERMIT CRAB, *1976*
Lithograph and colored pencil
22 X 30 IN.
Publisher: Stone Roller Press
On loan from the artist

THE POND, *1976*
Colored pencil on black paper
20 X 30 IN.
On loan from the Museum of Contemporary Art, Chicago

EUCALOL, *1977*
Acrylic on canvas
48 X 72 IN.
Collection of the Art Institute of Chicago

TAMIAMI, *1977*
Acrylic on canvas
72 X 48 IN.
On loan from the artist

TOAD, *1978*
Acrylic on canvas
48 X 36 IN.
On loan from the artist

STRANGE GAMES III, *1978*
Colored pencil on black paper
20 X 30 IN.
Private collection

STRANGE GAMES A (OXBOW), *1981*
STRANGE GAMES B (TALMADGE WOODS), *1981*
STRANGE GAMES C (EVERGLADES), *1981*
STRANGE GAMES D (LINCOLN PARK), *1981*
Four lithographs with colored pencil on handmade paper
48 X 36 IN. EACH
Publisher: Landfall Press
Private collection

CHROMOS I, II, III, IV, *1982*
Acrylic on canvas
60 X 48 IN. EACH
On loan from the artist

ENDANGERED, *1982*
Acrylic on canvas
48 X 144 IN.
Collection of the National Museum of Women in the Arts

LEAP FOR LIFE, *1984*
Acrylic on canvas
48 X 48 IN.
On loan from Roland Ginzel

CASCADE, *1984*
Acrylic on canvas
72 X 48 IN.
On loan from the artist

BOMARZO FISHBOWL, *1984*
Acrylic on canvas
40 X 24 IN.
Private collection

BLACK EGRET, *1985*
Lithograph with colored pencil
44 X 30 IN.
On loan from the artist and Landfall Press

EAGLEBEAK, *1985*
Lithograph with colored pencil
44 X 30 IN.
On loan from the artist and Landfall Press

ROCKFACE I & II, *1986*
Acrylic on canvas
12 X 16 IN. EACH
Private collection

STUDY: CHROMIUM TRANSPOSITION (DOG), *1986*
Acrylic on canvas
12 X 16 IN.
Private collection

EVIDENCE OF LIFE/BALLYNAGEERAGH, *1989*
Acrylic on canvas
54 X 72 IN.
Courtesy of Jean Albano Gallery

EVIDENCE OF LIFE/BROWNESHILL, *1989*
Acrylic on canvas
54 X 72 IN.
Courtesy of Jean Albano Gallery

**PROTRACTORED TIME &
WEIGHT AND SEA**, *1989*
Acrylic on canvas
22 X 18 IN. EACH (TWO PIECES)
On loan from the artist

HISTORY OF THE WORLD I, *1990*
Colored pencil on black paper
30 X 44 IN.
On loan from Donald Ercole

MIRABAI, *1990*
Colored pencil on black paper
20 X 30 IN.
Courtesy of Printworks Gallery

THE ELEMENTS, *1991*
Lithograph with colored pencil and watercolor
60 X 90 IN.
On loan from the artist and Pondside Press

PERSISTENCE OF INVENTION, *1991*
Acrylic on canvas
36 X 48 IN.
On loan from Andrew Ginzel

WITNESS, *1991*
Acrylic on canvas
24 X 28 IN.
On loan from Barbara Klawans

ONE OF MANY TROPHIES, *1992*
Acrylic on canvas
36 X 72 IN.
On loan from the artist

THAYER'S (DIS) ILLUSION, *1992*
Colored pencil and gouache on black paper
25 X 40 IN.
On loan from the artist

ELEPHANTINE, *1995*
Acrylic on canvas
60 X 84 IN.
Private collection

HURRICANE TIME, *1995*
Colored pencil on colored paper
20 X 25 IN.
On loan from Kristin Jones

NEVER INHALE, *1995*
Colored pencil on black paper
20 X 25 IN.
Courtesy of Printworks Gallery

ENDANGERED/COCKATOOS, *1996*
Acrylic on canvas
36 X 48 IN.
On loan from the artist

**THE MYSTERY EXPLAINED
(LILIUM CANDIDUM)**, *1996*
Colored pencil on black paper
38 X 25 IN.
Private collection

NAUMKEAG, *1996*
Acrylic on canvas
45 X 52 IN.
Courtesy of Jean Albano Gallery

RED ALERT, *1998*
Acrylic on canvas
20 X 16 IN.
On loan from John Cain

HOMAGE À POYET/PARROT POYET, *1999*
Acrylic on canvas
44 X 52 IN.
Private collection

HOMAGE À POYET/MEGA TANGO, *1999*
Acrylic on paper
18 X 24 IN.
Courtesy of Printworks Gallery

HOMAGE À POYET/BLUE INVENTION, *1999*
Acrylic on paper
18 X 24 IN.
Courtesy of Printworks Gallery

**HOMAGE À POYET/
DOMINOES AND DRAGONS**, *1999*
Acrylic on canvas
44 X 52 IN.
Courtesy of Jean Albano Gallery

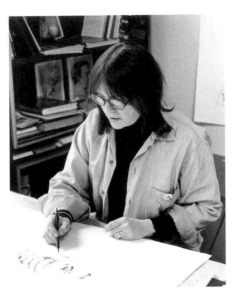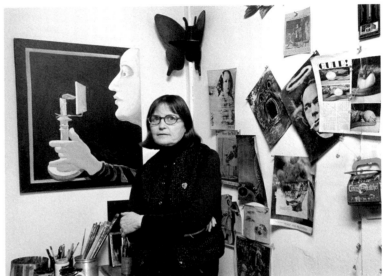

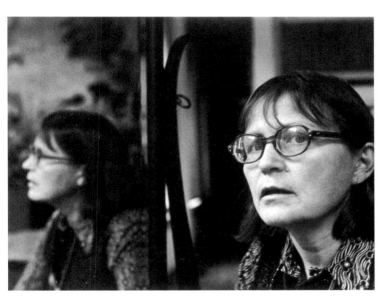

PUBLISHED ON THE OCCASION OF THE EXHIBITION:

ELLEN LANYON: TRANSFORMATIONS, SELECTED WORKS FROM 1971–1999

AT THE NATIONAL MUSEUM OF WOMEN IN THE ARTS
1250 NEW YORK AVENUE, NW
WASHINGTON, DC 20005
DECEMBER 23, 1999–MAY 7, 2000

COVER: *Homage à Poyet/Parrot Poyet*, 1999, 44 X 52 IN.
INSIDE FRONT AND BACK COVER: DETAIL FROM ELLEN LANYON'S COLLECTION OF NATURAL FORMS, ECCENTRIC OBJECTS AND SOUVENIRS
PAGE TWO: DETAIL FROM ELLEN LANYON'S OFFICE DESK AND WALL, NEW YORK, 1999
PAGE FOUR: ELLEN LANYON'S CURIO CABINET, NEW YORK, 1999
PAGE THIRTY-TWO: DETAIL FROM ELLEN LANYON'S STUDIO WALL, NEW YORK, 1999
PAGE FIFTY-EIGHT: CERAMIC TOBACCO JAR, TOAD, COLLECTION RICHARD LANYON

PROJECT DIRECTOR: LAUREEN SCHIPSI
TEXT EDITOR: LISA SIEGRIST
DESIGN: ALAN HILL DESIGN, NY
STILL-LIFE PHOTOGRAPHY: RICHARD SYLVARNES
OTHER PHOTOGRAPHY: JOHN BACK, WILLIAM BENGTSON, D. JAMES DEE, OGDEN GIGLI, JOAN SAVIO, RICHARD SYLVARNES
PRINTER: THE STUDLEY PRESS, DALTON, MA